Home*less*

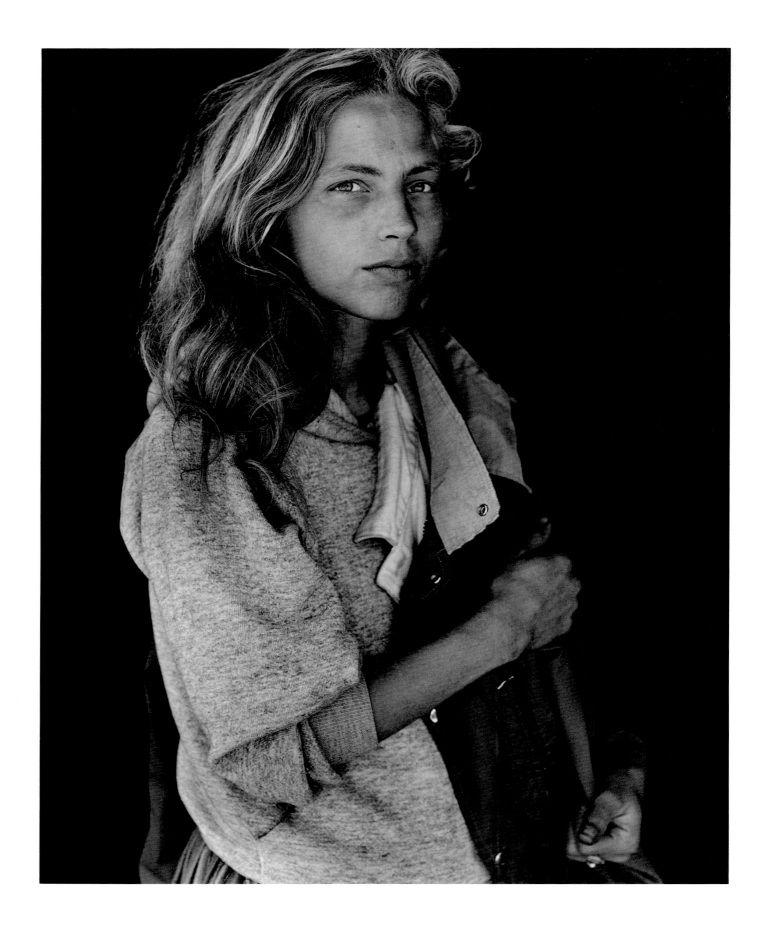

PORTRAITS OF AMERICANS IN HARD TIMES

Homeless

Photographs by Howard Schatz

Project Director and Editor: Beverly J. Ornstein

Design by Milton Glaser
Foreword by Owen Edwards
Afterword by Marilyn Winkleby, Ph.D.

CHRONICLE BOOKS

SAN FRANCISCO

Other books by Howard Schatz:

Gifted Woman Pacific Photographic Press, 1992

Seeing Red: The Rapture of Redheads Pomegranate ArtBooks, 1993

Text and Photography © 1993 Howard Schatz

ISBN: 0-8118-0512-3

Printed in the United States of America by Gardner Lithograph.

Library of Congress Cataloging-in-Publication Data available.

10 9 8 7 6 5 4 3 2

Distibuted in Canada by Raincoast Books
112 East Third Avenue
Vancouver, B.C. V5T 1C8

Chronicle Books
275 Fifth Street
San Francisco, California 94103

Larry Clark, one of the people I photographed, described his life like this: "pulling tears, saying prayers, and begging for mercy."

This book is dedicated to the many people I met in the streets who gave of themselves. There was a willingness to share, to teach me, and to help others by allowing me to make and publish their portraits and tell their stories.

And to Ms. Gladys Valley. Her remarkable generosity made the publishing of this book possible. Her heart is truly in the right place.

INTRODUCTION

Sometime in the early 1980s, I saw a middle-aged woman sitting on a downtown street, her back against the wall of a shop. She held a sign that read, "Hard Times," and in front of her sat a cup. She gazed straight ahead, not looking anyone in the eye, as if not to be seen. Business people and shoppers walked by. At the time, begging on city streets in the United States was rare and the sight of this woman shocked me and moved me.

I watched the woman from a distance, although I felt I was doing something wrong. I was staring at her! Although I had my camera with me, I felt it would be wrong to make a photograph of someone who seemed so desperate and vulnerable. Yet, making photographs is my way of seeing and understanding the world. In order to know who she was, I needed to see her and to make a photograph; and I wanted others to see it.

I began to talk with homeless people and to ask them about themselves. I would introduce myself, sit down on the sidewalk with my back to a wall—shoulder to shoulder—and I would strike up a conversation. In the course of the conversation I would ask: "Where do you sleep, is there a toilet you can use, can you bathe, what do you do for food? Where are you from, how did this happen, do you have a family? Is there hope to change your state of affairs?" Most people I approached readily spoke with me and gave me their stories. Afterward, I shook hands and left some money to express my gratitude. After talking with many homeless people, I felt confident that a photographic project was possible.

I began the project by walking in the streets with my camera. I carried with me a dark cloth and some tape, film, a light meter, releases, a pen, and a tape recorder. When I saw

someone whom I wanted to photograph, I stopped, introduced myself, and shook hands. After establishing that the person was in fact homeless, I told them that I was doing a photographic project, explained what it was about, and asked permission to take photographs. Each time after that, I brought photographs from previous sessions to show to each person I met. Most of the people I asked agreed to participate in a portrait session and the recorded interview that followed. Some people allowed me to photograph them but did not wish to, or were unable to, tell me much about themselves.

I wanted to see—to look directly at each face. I used a dark cloth as a backdrop, so that no other information (locale, street signs, other people) would distract from the eye-to-eye, face-to-face experience. I taped the cloth to a north-facing wall and proceeded. A hand-held, motor-driven Hasselblad camera allowed me both easy movement and spontaneity. I asked each person to look at the camera and directed his or her position to some extent. I never suggested a mood. During the session, I conversed, asked questions, responded, and tried to share some of my life, always attempting to be respectful and warm.

As the project progressed, I learned that there were certain areas where there were many homeless people, and that I didn't have to walk, searching. I set up a simple outdoor studio: two tall stands with a connecting, horizontal pole on which a dark cloth was hung. Because there was a large number of people to photograph, I required the help of an assistant to load film and keep track of names and releases, and someone to do the interviews. When I saw someone I was interested in, I asked if I could have some of his or her time to make a photograph for this project.

I rotated locations, returning to each periodically and regularly with 8″ × 10″ prints from the last session there. When someone I had photographed previously came by, I gave that person a copy of his or her photograph. This resulted in some remarkable and wonderful moments and helped create some trust, or at least comfort, about me. My outdoor studio and helpers became a common sight in many different locations, and after a while, we were met with what seemed to be friendly recognition. This connection helped enrich the photographs. Some-

times people asked if I would take their picture so they could "be in the project"; so they could "let people know what it's like to be out here, homeless."

The people I met and the stories I heard helped me to understand, somewhat, the condition of homelessness. Most of us know that when people live "outside," unsheltered, in a street, they sleep in public parks, in doorways, on the sidewalks, in alleys, in abandoned cars or trucks, in public places such as bus or train stations, or in abandoned buildings. Runaway teenagers favor abandoned buildings and call themselves "squatters." Some people sleep in shelters and move from shelter to shelter. Some shelters offer only a bed and use of a bathroom. Some have showers and others provide one meal a day. Very few are "full-service" shelters offering not only living space but also counseling, guidance, and job referrals as well as a bed. Most shelters are emptied each morning. During the day, those who stayed there the previous night are in the streets, often in inclement weather, trying to find a way to feed themselves, stay warm, and finagle shelter for the coming night. These survival activities represent a full-time job, seven days a week.

Some people do receive some financial support: General Assistance currently pays approximately $170 every two weeks. This money, available to some, is used for housing (generally for a small room in a transient hotel, sharing toilets and showers) and lasts about two weeks or less. Any nights not covered must be spent either at a shelter or out-of-doors. And the money is never enough to cover food or clothing.

Others receive enough SSI (Supplemental Security Income—sometimes available to those who are disabled physically, emotionally, or intellectually, and incapable of working but still capable of dealing with forms and waiting in lines) or pension money to afford a hotel room but little else. They often beg, panhandle, forage in garbage cans, and stand in lines for meals and clothing.

Homeless people do not always look bad. Some are clean and neat and find ways, despite tremendous forces against them, to wash, shower, shave, and keep their clothing laundered.

The term "homelessness" can cover a very broad range of conditions and causes, but I

have learned, quite vividly, that for many, homelessness in a large part results from misfortune or accident: familial, emotional, social, and economic. An individual cannot choose his or her genetic makeup or skin color. One's social and emotional development, degree of parental care and guidance, family structure, and early education are not matters of choice.

There are many homeless people who are, to some degree, mentally ill. Many cannot concentrate, focus attention, or follow instruction. I met people who couldn't tolerate waiting in line the five or six hours necessary every two weeks to apply for General Assistance; some had a very hard time standing in front of my camera for more than a few minutes. I saw people in the street who, it seemed clear to me, were delusional, psychotic, paranoid, schizophrenic— defenseless. Many, like the "bag ladies" we have all seen on the street, kept on walking and never responded to me.

Some homeless people are addicted to drugs (heroin, cocaine, crack, etc.) or alcohol. I heard a number of times, "I'm an alcoholic, so I can't keep a job and can't pay my bills. I've tried everything, I've gone to AA many times and other programs. I've had counseling and psychotherapy. I stop drinking every day but I can't stay stopped. It's a disease, like cancer, and it's killing me. I can't quit the bottle, I can't quit. God knows how hard I try." Another statement was, "Crack, crack, crack. That's all I think about from morning to night. Everything I do is for getting it and using it."

And I met people just out of jail with nowhere to go: no halfway house, no job training, no guidance—lost. The only counsel they'd had were the lessons learned in jail.

And, finally, there were people who were homeless by virtue of the economic hard times experienced in this country in recent years. Many had been hard-working people able to support themselves and their families but who lost their jobs and had insufficient savings, family support, or other resources to pay for housing, food, and clothing. They were sucked into homelessness and the debilitating downward spiral that comes with it.

Homelessness rarely happens by choice. I know there are people in the street who say they choose not to work, who say they would rather panhandle or steal, whom some might call bums. These are people who are content, apparently, with doing nothing culturally or socially

meaningful, who seem satisfied to stand in soup kitchen lines, and who by anyone's standards seem to be "useless individuals." But it has been my experience that this is *rare*. The vast majority of homeless people are poor and vulnerable, struggling desperately and suffering helplessly and hopelessly. They don't know how to or just can't get out from under.

Working on this project, seeing these faces, and having these experiences have profoundly changed me. I never used to believe in luck. I used to think, glibly, that "luck is when opportunity meets preparation," or "you make your luck." I now understand the arrogance and ignorance of such aphorisms. Those things that allow us to become prepared and to cause opportunities to present themselves are themselves the result of a complicated set of positive circumstances, many genetic or developmental, and many over which we have little or no control. I was born with a reasonably good mind, into a loving home with two parents who provided an emotionally stable environment with structure. They taught me to be respectful, to revere education, and to work hard. And I was born white in the United States of America. I can take no credit for any of this. From such circumstances, it is much easier to build a life in which hard work brings success and living has dimension beyond the struggle for day-to-day survival.

Since the sight of homeless people in the streets has become so common, we have stopped noticing. We don't want to be caught looking. It is easier to keep on walking, to ignore them, and to imagine that they are not there. I made these photographs because I had to look.

Howard Schatz

San Francisco, California 1993

FOREWORD

On a certain autumn afternoon, at a busy city intersection, Howard Schatz has set up shop. At the curb, a backdrop of dark cloth is suspended from a portable aluminum framework angled to capture the light of an overcast day. While an assistant loads film, a casually dressed woman holds up a small tape recorder to catch the words of a man wearing several layers of mismatched clothing. The corner is busy, but few of those passing by pay much attention to the open-air studio. Those who do are men and women who, like the man being photographed, have no particular place to go and certainly no reason to hurry on. They stand nearby, discussing the scene and Schatz, whom they've seen before, watching with expressions that mix, more or less permanently, hope, need, and skepticism.

Schatz stands to one side, amiably at ease but watchful, a bulky camera around his neck and a blue baseball hat pulled down tightly on his head. He looks up and down the street until he sees something that gets him moving. Crossing the street, he falls into step with two bearded men, one wrapped in a grey blanket. Schatz begins talking, the threesome comes to a stop, and one of the two men turns and walks across the street with the photographer.

At this point, an ancient, unchanging negotiation begins between portraitist and subject. Both want the end result to be good, but the subject harbors a natural suspicion that the portraitist's notion of good may be something different than it ought to be, something selfish, subversive, and unflattering. The suspicion breeds tension, a tug between the sitter's sense of self and the artist's self-expression. This tug is inevitable, a given, whether it is between the

portraitist John Singer Sargent and the subject Madame X, or between a passport photographer and a traveler in a hurry.

But there is more to this sitting, and to the thousand or so like it Schatz has done in the past year, than even the usual complex relationship of artist and sitter can explain. His subject is a man, although many have been women, who last night slept in a doorway, or in a park, or under a railroad bridge. He has, perhaps, a cardboard box to call home and a shopping cart to carry around his belongings (scavenged, sorted, plastic-bagged), but that's about all. He may be crazy or addicted, unable to deal with the myriad, mundane complexities of everyday life, or simply down—disastrously down—on his luck. He may have an IQ of 68, or a college degree that has failed to work any magic. Whatever the reason, he exists now far outside the mainstream, unable to influence even the tightly constrained world around him, the object of institutional concern but rarely of personal attention, able to arouse pity or revulsion but engendering little affection and attracting notice less as a man than as an irritant to the collective psyche or an affront to the social compact.

When photographers take pictures of someone in this man's fix, they are usually doing documentary work. They want us to see context—the doorway, the box, the shopping cart packed with junk—because the goal is to capture the plight, not the person. Their photographs are a kind of journalism, usually with a distinct bias, and they capture precisely the scenes that most modern urban dwellers—those of us with places to go, things to do, bedrooms to sleep in—turn away from every day.

But Howard Schatz is a portraitist, not a documentary photographer. As a human being, he is concerned with the plight of the people who sleep in boxes and doorways. But as a photographer, he is interested in their faces, their clothes, and the way they present themselves to the camera. He is interested in not only who they are but how they wish to be seen. As a human being, he knows that the difference between homeless people and the rest of us is a matter of degrees: often many degrees, sometimes just a few. But as a photographer, he may suspect that they are a tribe apart, made unique and given a common set of rites and folkways

by the requirements of day-to-day survival. Thus, his pictures recall the nineteenth-century work of Edward Curtis among the native American tribes of the West. These are not documentary pictures, yet they document a historic moment through an intensive study of the person placed before the lens rather than through his or her surroundings or the grim, circumstantial evidence of loss and misery. The human face is the central fact conveyed: a fact, like most facts, open to many interpretations, but undeniable just the same.

* * * * *

When you get down to bedrock essentials, the act of photographic portraiture is quite cold-blooded. However diverting the subject, despite the celebrity or power or pathos of the person whose image is to be recorded, the requirements of light, focus, and composition cannot be ignored. Sympathy, curiosity, fear, hatred, love, or lust, the urgent need to tell a story, to shock, to convince, all are subservient to the necessities of craft, the passionless dictates of machinery and chemistry. For a photographer to tell the truth he or she wants told, the artifice of art must be exactingly employed. For the sitter, too, artifice is at the heart of the matter.

A portrait is a historical record of sorts, no less important to the contemporary person whose image is suddenly lifted out of the stream of time than Mathew Brady's craggy Lincoln or Yousuf Karsh's glowering Churchill. Even in an age of ubiquitous Instamatics, the sitter for a formal portrait may sense that at the moment the shutter clicks, the future is watching. So, if the photographer uses people to make art, people return the favor, using photographers to *become* art. No matter how many millions of portraits have been made since Monsieur Daguerre clamped his first client into position, the camera can still seem important and can confer glamor and importance on the mere mortals placed before it. Mountains, monuments, prairies, skyscrapers, rivers, and boulevards have all been seen before, but not *this* face at just this moment. Great portraits can be made only when photographers and subjects are secret sharers of this belief.

What Howard Schatz has done to make the extraordinary portraits in this book is to create a collaboration between himself and people who would seem to have little reason to want to

be photographed. They have been left out of history, whether or not they happen to be included as statistics in the debates on public policy. They are mostly lost to their families and unwanted by businesses and neighborhoods—comprehended as numbers more than names, visual evidence of society's ills more than human faces.

But not to Schatz. In the best tradition of photographic portraiture, with that rare, affable ability to gain trust that lifts the form to its most memorable height, he has made a record of people in the grip of hard times—not as symbols of human need, but as themselves. For a few minutes, they are the center of attention. By dedicating himself unequivocally to the act of photographing and by giving both subjects and viewers the dignity of art's formal distance, Howard Schatz renders irrelevant the dangers that lurk in photographs of the poor and downtrodden—the sympathy that can so easily become smug, the pathos that leads to patronizing, the sense that "there but for the grace of God go I" that can lure us into relief and a self-congratulatory sort of comfort, the shock that arouses first shame and then rejection. Schatz offers respect for his art, for those who are the focus of that art, and for those who view it. The message we take away is up to us. He doesn't grab us by the shoulders and shout, "Feel sorry!" Instead, he turns us toward the light and says, simply, "Look."

Owen Edwards
San Francisco, California 1993

EDITOR'S NOTE

The people whose portraits appear in this book were not always able or willing to talk with the photographer. In addition, some of those who did consent to be interviewed still withheld their full name or their age or their place of birth. For this reason, not every portrait is accompanied by the same information. The majority of these portraits were taken in San Francisco, California.

Homeless

The Portraits

Bernie O'Reilly, 61 CHICAGO, ILLINOIS

I worked as a printer and then went into the service, Korean War. I came back from the service—you know you're lucky when you come back—and I went back to the job, printing, again. Then the '58 Eisenhower recession hit so everything folded up and I went back to Chicago. I worked for the newspaper, and after they automated, that was it. I was fifty-five, I guess. I'm sixty-one, and I go to the soup kitchen. I tried four times for General Assistance and got nailed with technicalities every time. I should have a pension. They ran off with our one pension, the union, and so they started another one, and I never got enough accumulated in it; but I should get something out when I'm sixty-five. I'm waiting for Social Security now.

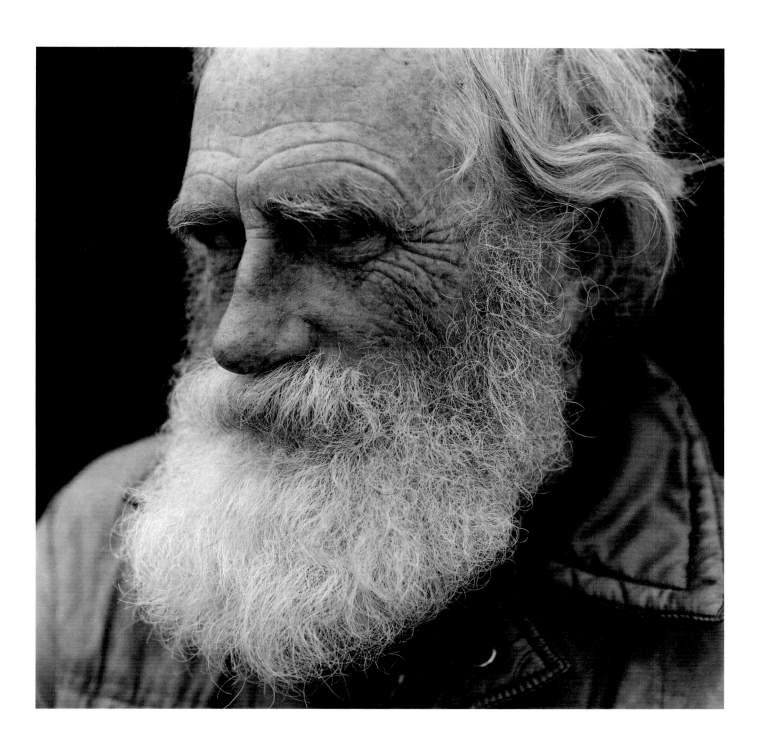

Elizabeth, "Goddess of the World"

The streets is my home for more
than thirty years. Don't need no
roof.

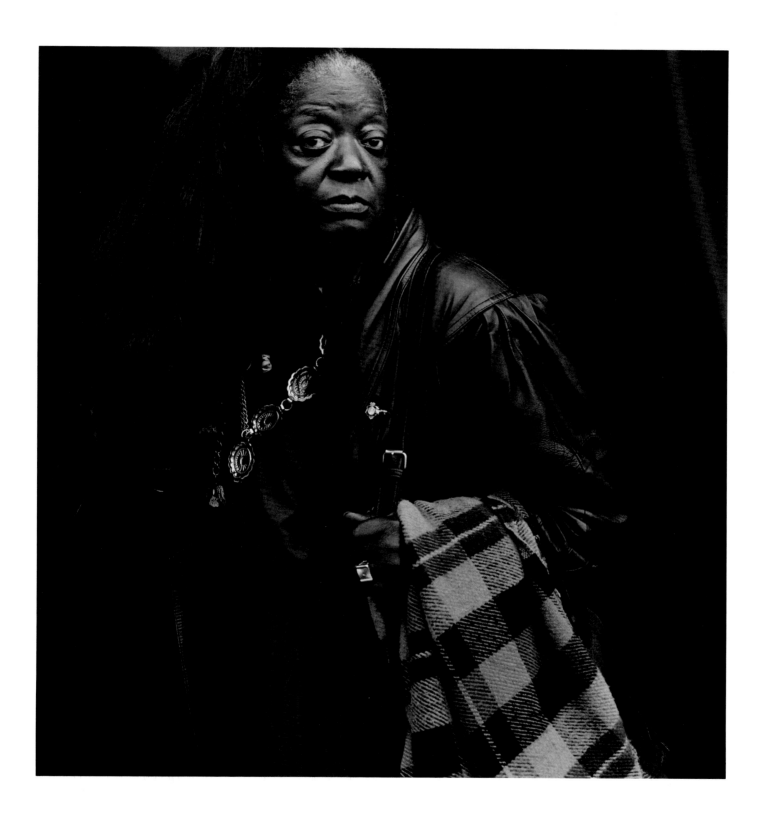

William Hagar, Patrick Swift, AND Nathan Swift EUREKA, CALIFORNIA

William: I don't think in America anybody is forced to be out in the street, because you can always get assistance and help if you go through the channels. Although we should take care of our own a little bit better in this country. People that want to be out here are people that have been let down by the establishment.

Patrick: I'm an ex-computer programmer, but I dropped out of society because I didn't feel that they treat any of their people right, including the homeless. They send aid to other countries, while people here are starving to death in their country. And this is just my way of letting society know, that, "Hey, I'm not with you. I'm out here 'cause I want to be out here." And I truly do believe that a lot of the homeless are the real America. I did one and a half years in the joint. I can get a job right now. But I refuse to pay taxes. The hell with that. There's a lot of little kids you see out on the street. Youngsters coming out for the first time. There's all kinds of drugs, crack, gangs and violence, and stuff like that. And I try to discourage them from that and encourage 'em to be themselves. If you want to hang out, that's cool, just don't hurt anybody while you're doing it.

William: I would say that maybe eighty percent of the people truly want to be out here, and I'm more happy here because I say that society is just so much bullshit red tape. You're out here, you still have your freedom to make your own choices. You don't have to worry about the stereotypical attitude of your parents. I was having problems with my wife, but when I came out here, I realized what it really is in America. You have to fight every day to live. Out here, it's not so much of a struggle. You might go hungry for a day, but other than that, you don't have to wear your suits and ties, and you don't have to be clean-cut to be accepted. I don't think I'll ever go back home. Unless my people die, and then I'll go to the funeral.

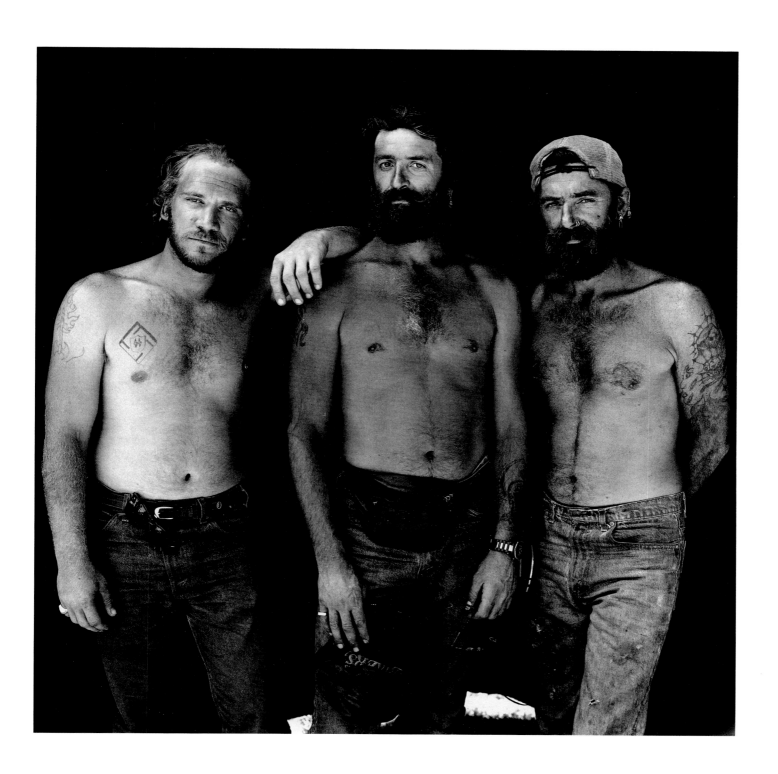

Nora Balestrazzi, 80 PUERTO RICO

I was always a very bright student. I got a scholarship to go to college in the United States in Ohio at the Western College for Women in Ohio, which is part of Miami University. And I stayed there two years, then I went to New York City and went to Hunter College. Then I came to California as a teaching assistant in the university. I worked. I have three children.

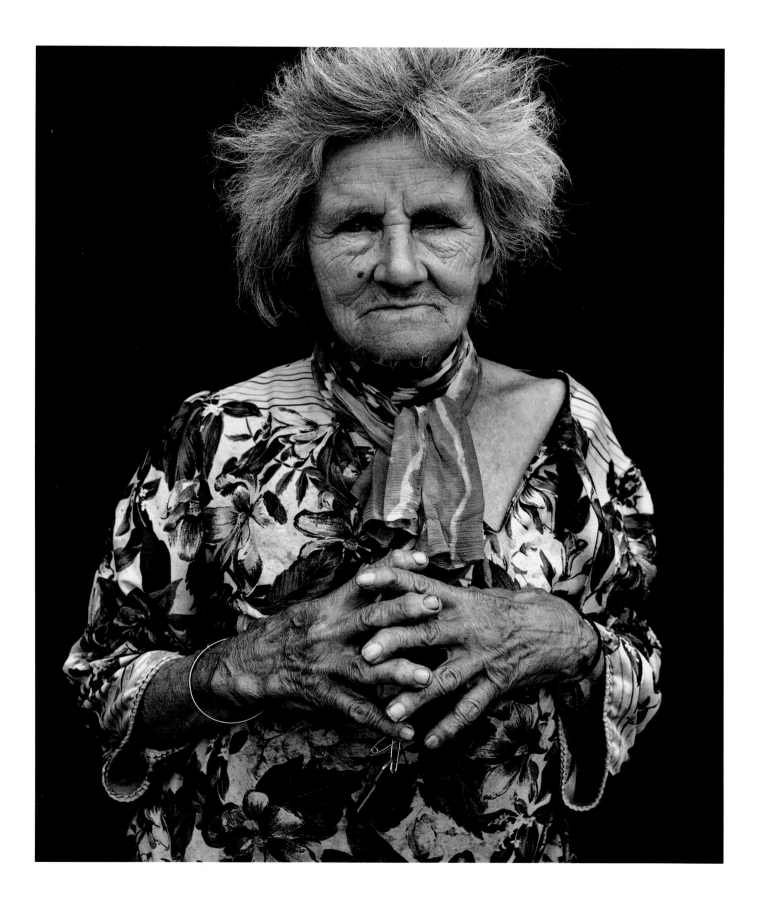

Michelle Chyrn AND SON, Ray

I'm looking to get into a hotel.
Got kicked out of the last hotel.
Can't stay too long because it
would be declared residency. If I
have residency, can't get benefits,
so I stay in a hotel for a minimum
of time and keep moving from
hotel to hotel.

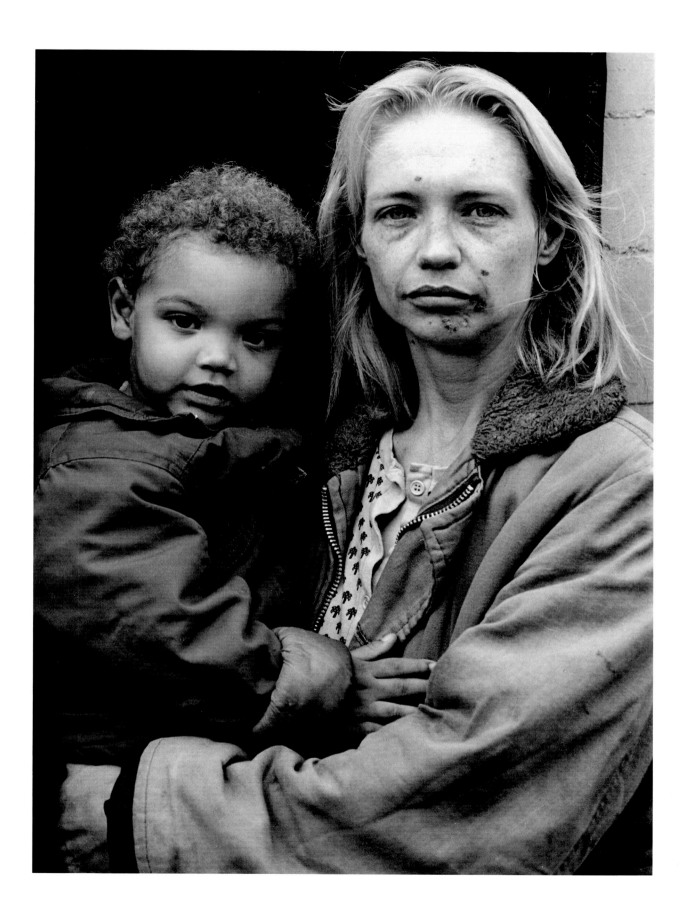

Donald "Boxcar" Johnston DETROIT, MICHIGAN

I'm a professional hobo and a UFO-ologist. I was walking home one night and I was terrified; I saw this strange craft coming over. I was on the grounds of the Wayne County General Hospital when I saw this strange craft coming toward me. It was up pretty high and it was strange, the way it looked. They also knew the very moment when I was going to be there. And they stopped, hovered over me, and studied my reactions to them. Fortunately for me, I wasn't hurt. They hovered over me for a while and then they put on a burst of speed suddenly; and then they stopped again and hovered for a while a little way from me. When the ship got real bright when they put on the burst of speed, I could see the shape of a saucer. And then they went away toward Detroit. They were sending strange waves toward my forehead. That's why I couldn't move. I tried to run and scream, but I couldn't. I was frozen to the spot.

I've been studying them for many, many years. I'm a member of the space brotherhood; there's good ones and bad ones out there. The bad ones are called grays, and the men in black, they're the evil ones. Then there are the good ones, which are here to help us. There are some of them in our government, too. Some aliens in our government. Both good and bad. And I've been interested in this for many years. I buy the magazines each week: the *National Enquirer* and the *News* 'cause they tell you strictly the truth. Tell the whole truth. Our ancestors originally migrated from space. Our scientists discovered evidence of this. They're the ones that built the pyramids. These space aliens did. They built pyramids as well on the planet Mars. That's been photographed by our machines going to Mars. . . .

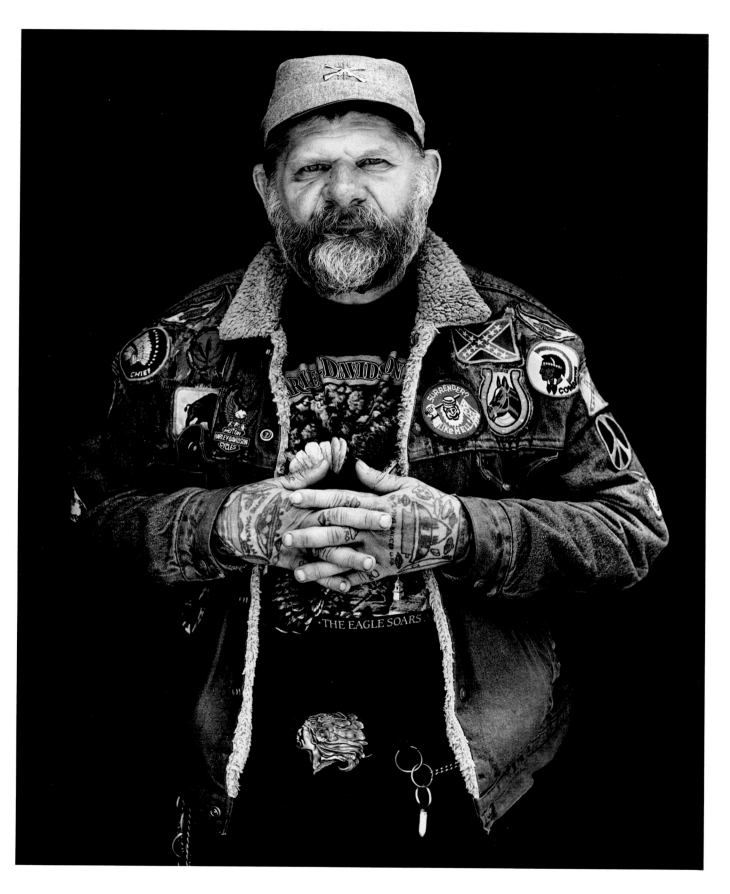

Stella Robinson, 43 VALLEJO, CALIFORNIA

I'm makin' a move to get on my feet, to have something. I used to be a presser. I used to be a worker. I used to work in factories. Laundry. It's been a while back, but that's my thing. Then I had my kids, and I raised them off of AFDC.

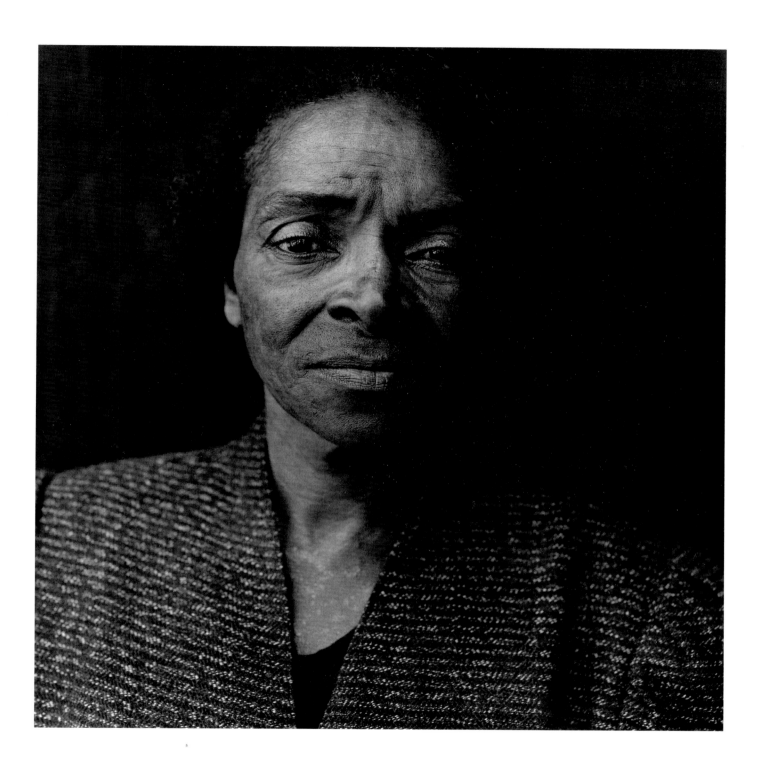

Chris Owens

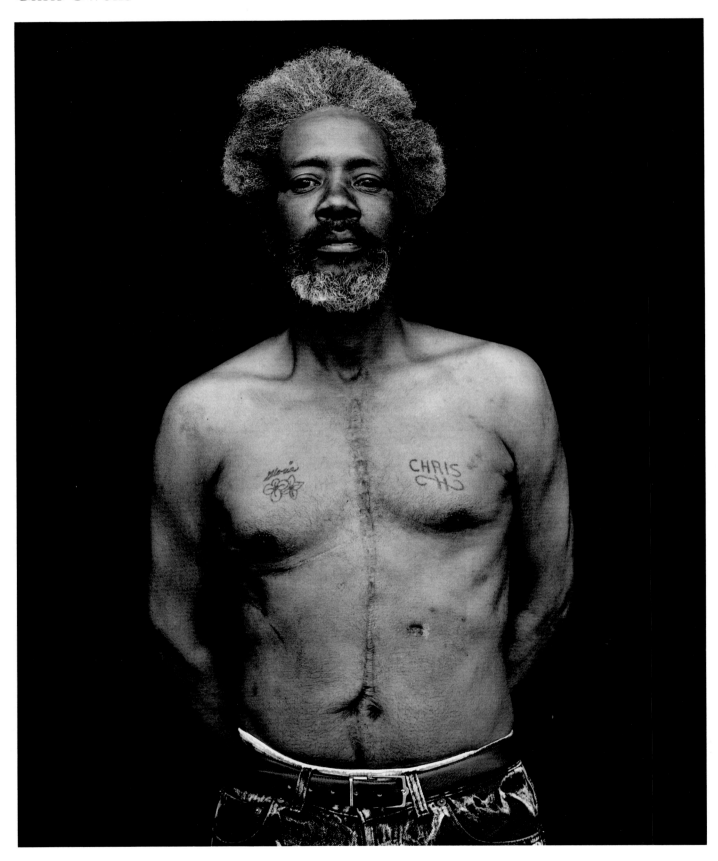

Tobias Warren

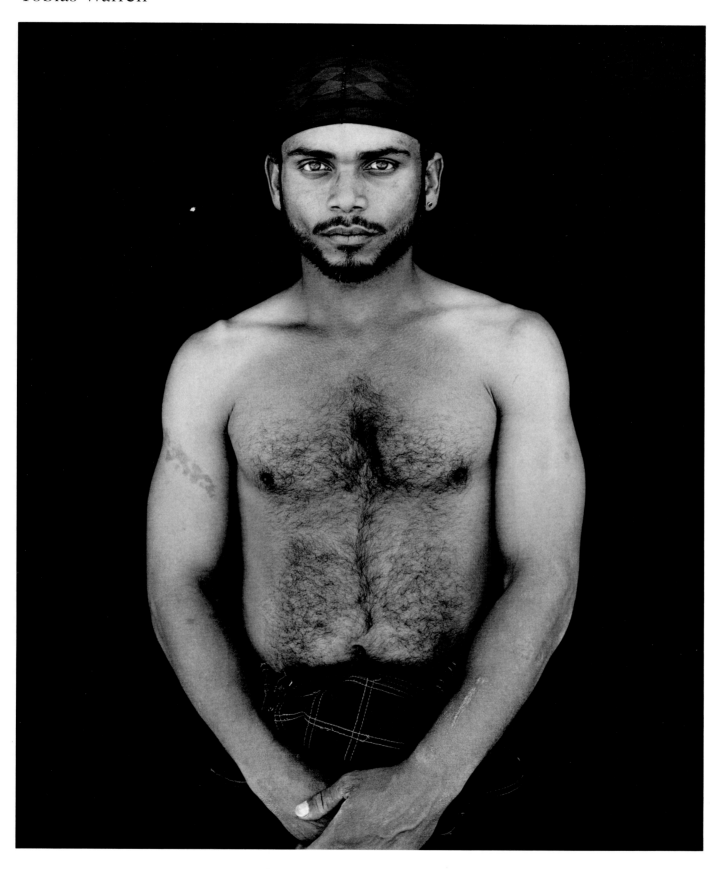

Eugenia Teaford, 58

I have my master's degree from San Jose State, my degree from Heald's Business College, and I've been a secretary for twenty years. Executive secretary, the Board of Directors of Stockton and St. Petersburg, Florida. Now, I've saved money for years, a true story. I went to Canada, and I went to Lourdes, France, and I took all my savings over there. Torremolinos, Spain; Tangiers; Montevideo, Uruguay; and I've spent three years in Argentina.

In 1985, President Alfonsin attempted to assassinate me, and it took President Reagan's daughter to get me out of Argentina in 1985. She had to come down there; I got in a mess like Terry Anderson over there and I was really bad off over there in Argentina. I had my savings in Argentina, and Argentina stole half of my savings from the bank; it took President Reagan to get me out of Argentina. So, I came back in 1985 without my savings that I've saved for years; now I'm broke. I live at the woman's shelter and come out and pan-handle to get a little money. I'm getting old. I raised five children and all my children are working and very happy, but they don't want Mother around. They were very angry that I went to Argentina and spent all my money traveling. They said, "Mother, you should have stayed at work instead of enjoying yourself."

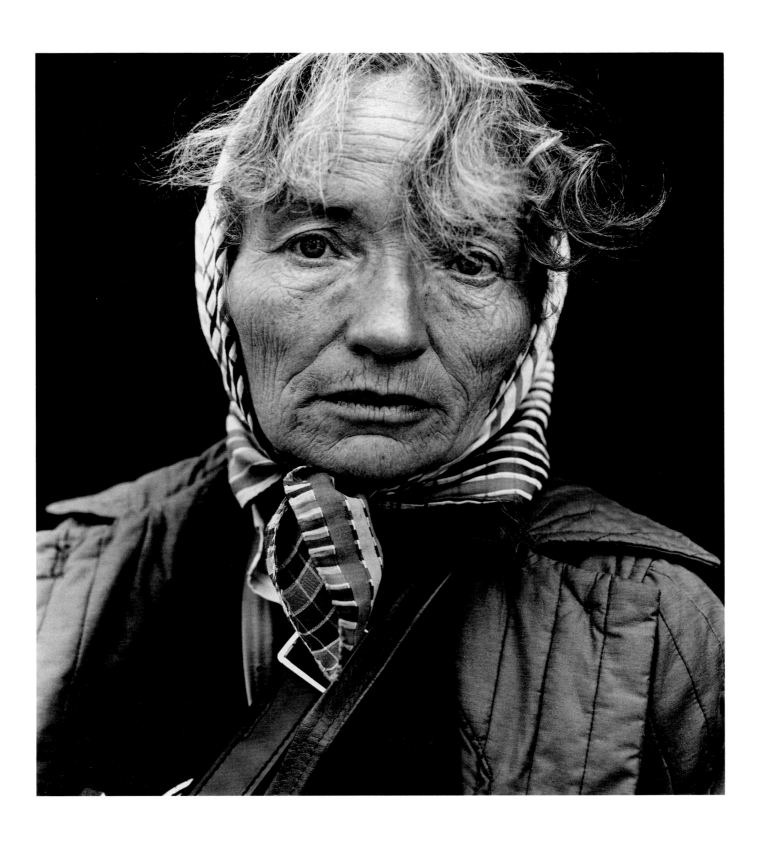

Arnold McLean, 34

I tried getting jobs just about
everywhere, but I'm being
discriminated against because I
did a little time in the joint for
grand theft auto about five years
ago. I know how to cook, wash
dishes, move house, mow lawns,
and trim hedges. I've got applica-
tions just about all over San
Francisco, but they don't want
me. I don't have a telephone and
I don't have an address. "We can't
use you, thanks for coming by
anyhow . . . ," and they got Help
Wanted signs all over the place.

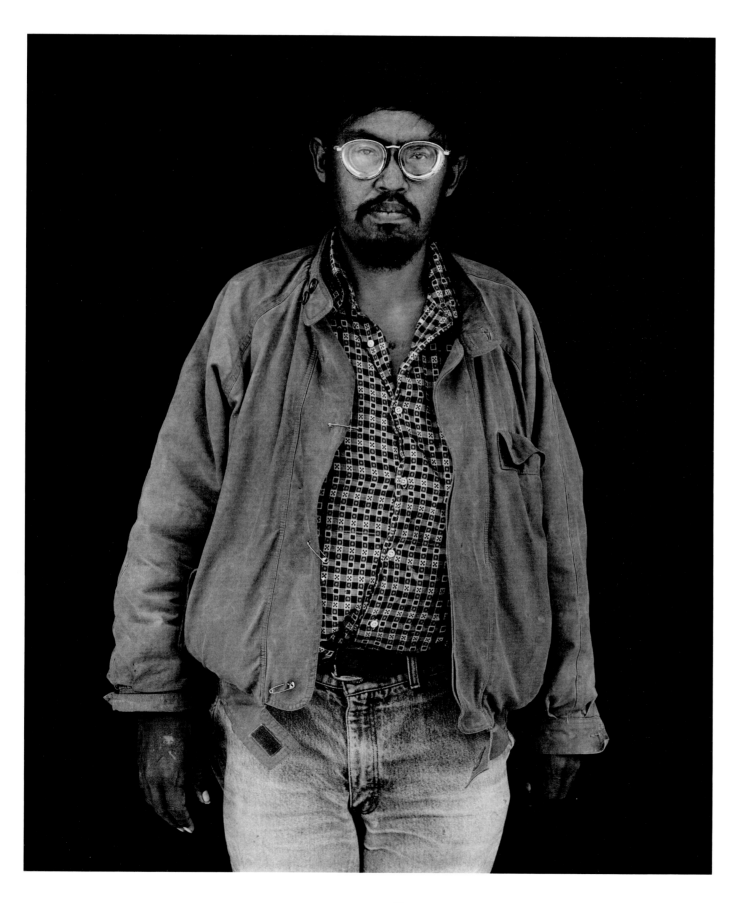

Deborah Williams, 38 AND DAUGHTER, Jasmine, 8 SAN FRANCISCO, CALIFORNIA

If you work and you are on welfare, as soon as you make a dime, the government takes a nickel from you. So, I was trying to get out of the projects from the start. And once I started working, I never reported that I was working. And they go by your gross income. I was going by my take-home income, and they charged me a whole lot of back rent, which I just refused to pay it where I was staying. The area, it was too bad, so I waited until the last minute. Well, actually, I must not have wanted to stay there. I just didn't care. It got to that point. The sheriff's department came out and evicted me.

I'm going to make it, I'm not worried.

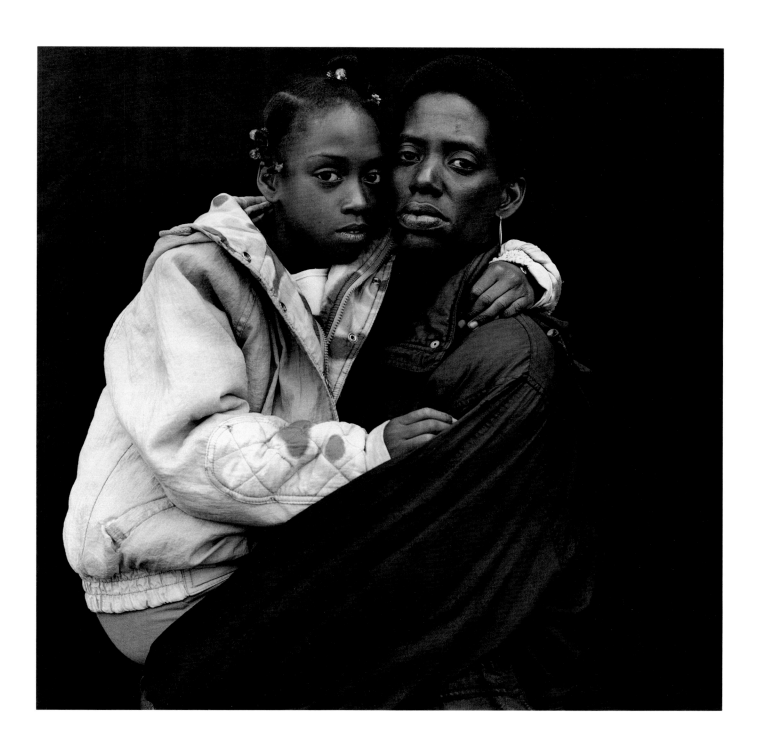

Robert Schuderer, 58 SAN FRANCISCO, CALIFORNIA

I'm not what you would call homeless. My home is on my back. I've been living outside for about ten years. It happened to me 'cause of my misactions. That's when I was working. I lost a job. I was a security guard. The job got to interfering with my drinking.

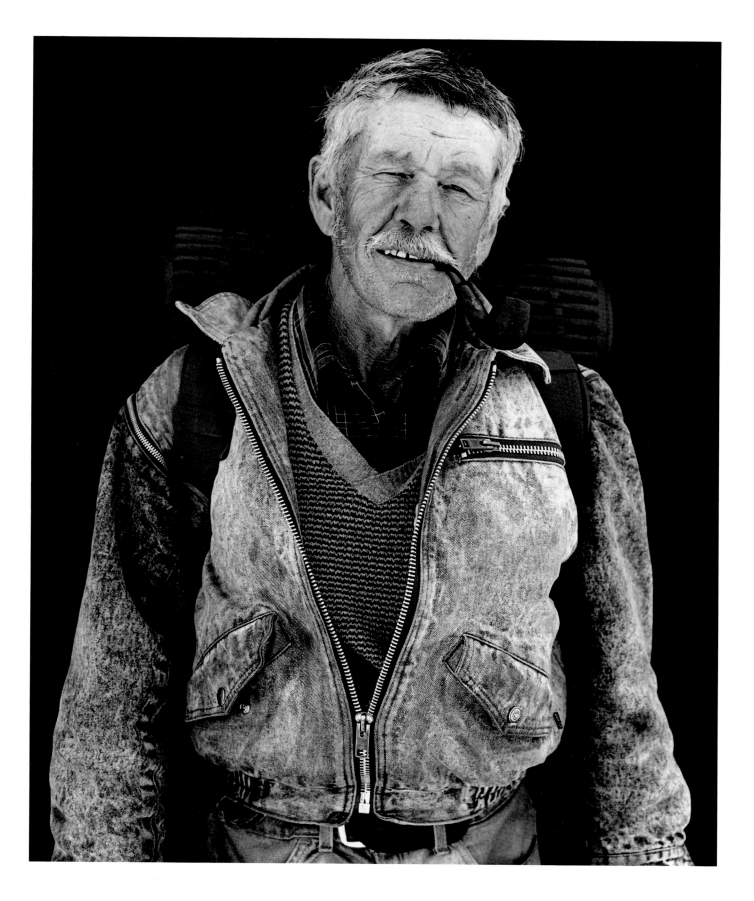

Michael Hayes, 21, MISSOURI, AND Maureen Kennedy, 18

My dad seemed to hate me. He was always hitting me for some reason. I didn't do that good in school. I was considered a failure by both my parents. So I just got out.

I still call my parents once in a while, but if I don't lie to them, then I hear all these lectures about "you're messing up your life, you're screwing up, when're you gonna straighten up." I get sick of hearing that so when I call my parents, I say, "I'm doing good; I have a nice apartment; I have a job." It hurts me inside to do that, but I still love my mom and I don't want her to worry about me. I tell her that I'm doing really good even though I'm not. I'm homeless, I'm staying in an abandoned building a couple of blocks from here.

I've had jobs. I've had a nice hotel room. It seems like I have everything going for me; and then all at once, it's gone and I have nothing again. I don't know what it is about me that makes that happen. It's been about five, six times so far. I've been a bike messenger but I don't have a bike anymore, and the companies are really full. And I can't even get a job because I don't have a place to stay. I don't have any kind of way to wake up, to go to work, or anything like that. I don't have a phone number to give them, an address, or anything, so I really can't get a job until I get a place to stay.

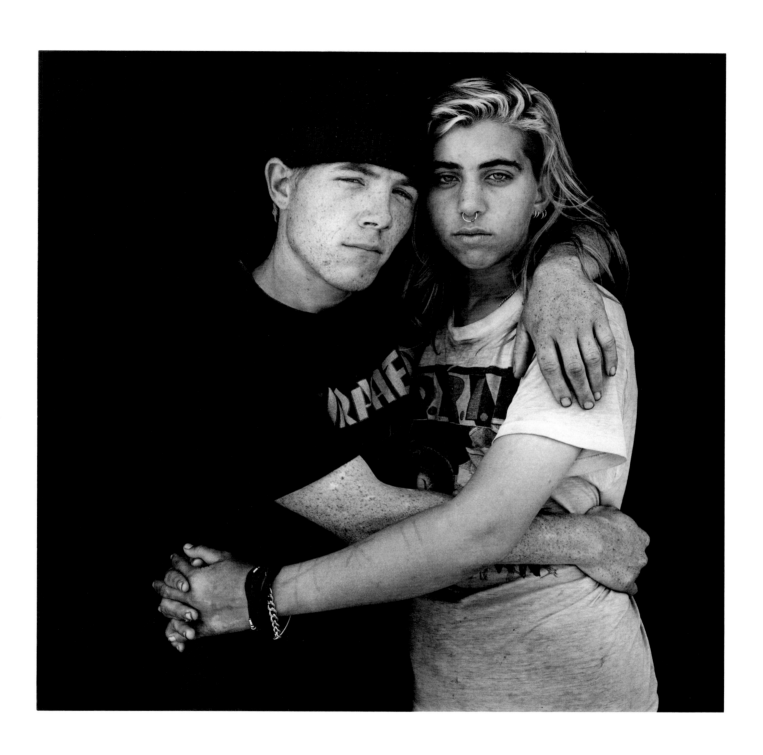

Lindsay Calome

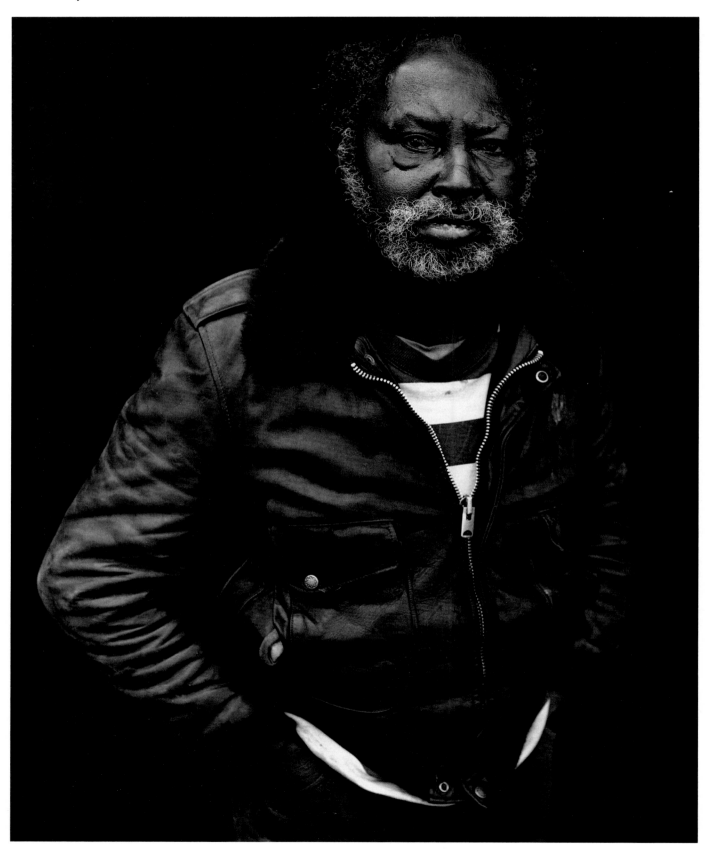

Nahan Marera

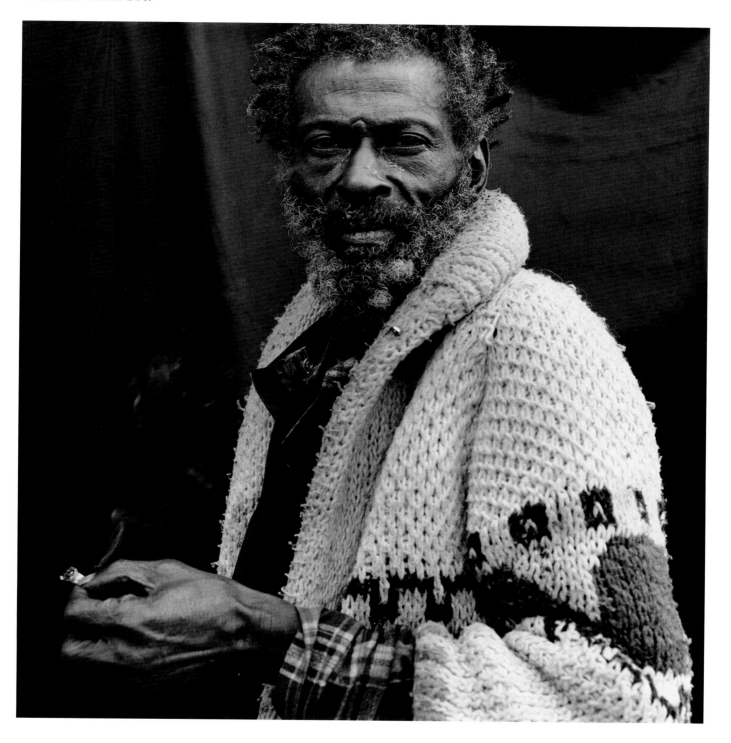

Sue LaRue

So many times I hear people say they're so sorry. Sorry because I'm homeless, or sorry 'cause they can't help me, you know, but I hear that word so many times a day—but I tell you, there's a few people out here, man, they've got a heart, they've got a good heart. But if they don't have something to give, they stop and say, "Hi, how're you doin'?" you know, "Did you have shelter last night?"

The hardest thing is being a woman and living out here. My girlfriend, she and I have been knowing each other for five years, and we were staying out there in the brewery, that's what I call it 'cause that's where they used to make beer. She stayed in one room and I stayed in the other room, and we would look out after each other. If I woke up before she did, I'd go in and wake her up; or if she woke up before me, she'd come wake me up, you know. I woke up in the morning to wake her up, man, and somebody had shot her in the head. And it took me a long time, 'cause I felt so guilty, man, why I didn't hear that sound, you know. You'd be surprised how many homeless people die in the city a year. Probably not people that I know personally, but I know a lot of faces 'cause a lot of people I see out here, I stop and I say, "Hi, how've you been doin'?"

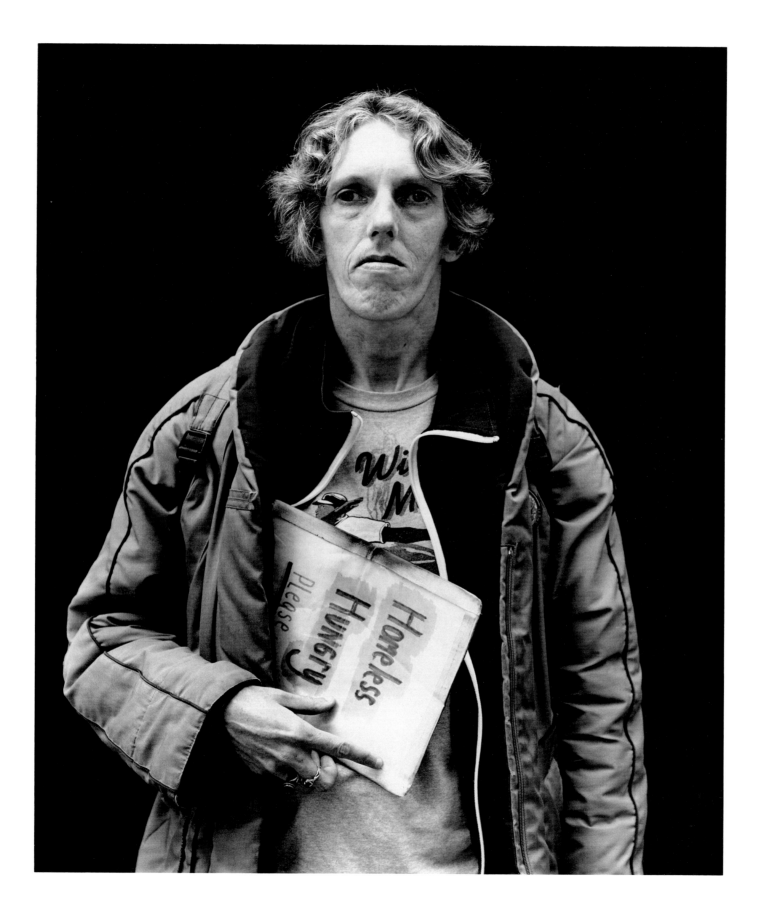

John Psyche Mendess, 68 UPSTATE NEW YORK

Ran away from home on my tenth birthday in 1934. The Depression was at its height. I found out what it was to be hungry. I learned to make my way. Worked here, worked there, dug here, dug there, sometimes I did a few things that were somewhat illegal for survival, but I did the least harm as I could.

I was raised by Gypsies part of my childhood. Mom was heading towards her aunt's place, where she was going to give birth. On the way there, during a rainstorm, she gave birth to triplets. Along comes some Gypsies who see what's going on and say, "Hey, those kids are going to die of pneumonia." So, they set up a tent, built a fire in there, and got us warmed up by dunking us in hot water and wrapping us. Three days out of their way they went to take us to mom's aunt's place. When we got there, the old gentleman who was married to mom's aunt said, "Hey, you've done a wonderful thing, a noble thing. We can't set up a stone monument to you, but we would like to give you a monument that will last as long as those children will live. Two boys, one girl. Triplets. Could you give us two Gypsy fellow's names and one Gypsy girl's name?" I'm Psyche, my brother's Vlacho, and sis is Saveta.

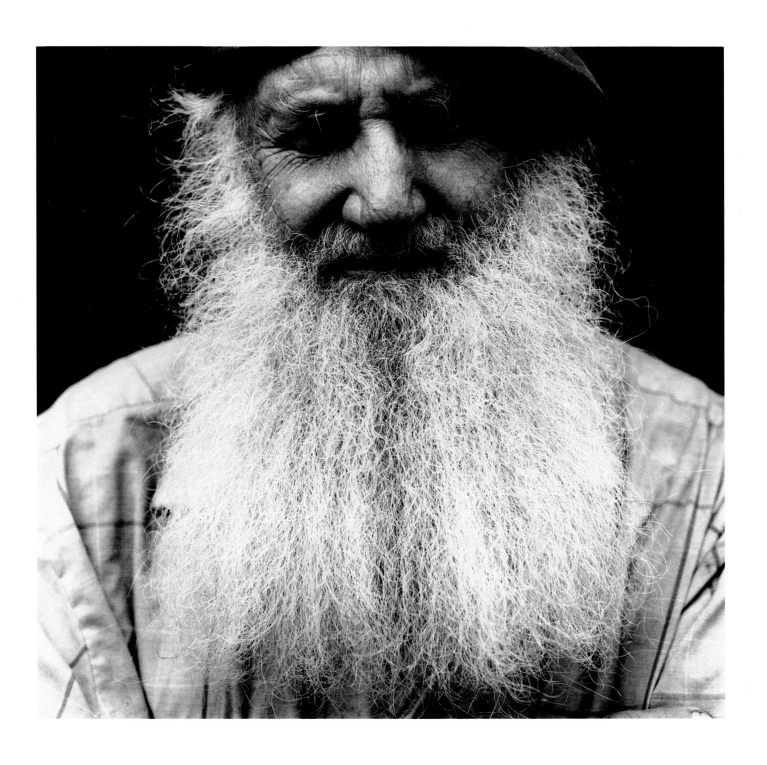

James Duitman, James Meginiss, AND Masis Nagle

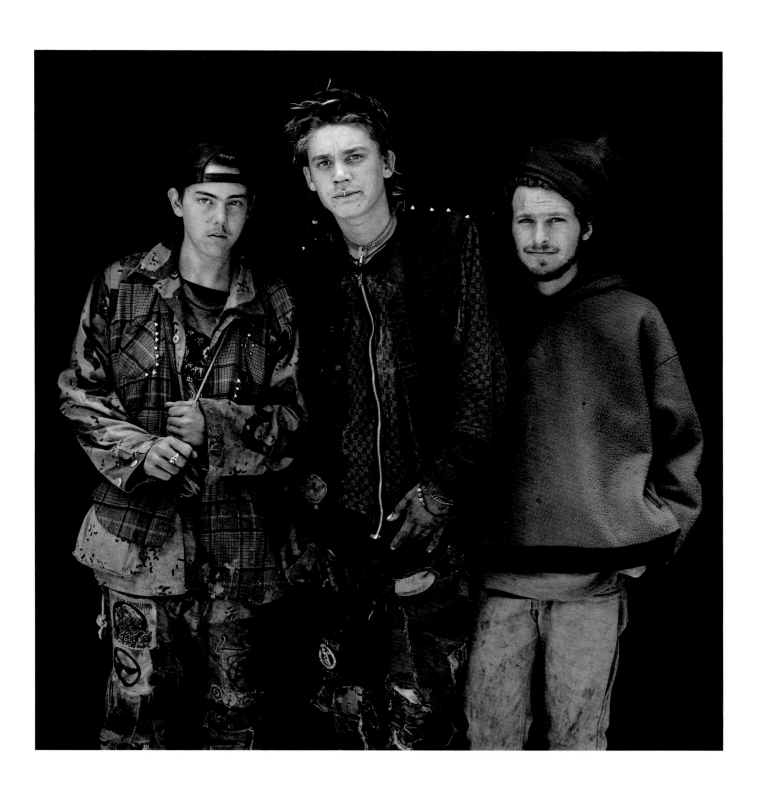

Wanda Ledesma RIVERDALE, NEW YORK

I've been to school. I've been a
bartender. I've worked in the
financial district, but I don't want
to do that no more. I'm a heroin
addict. I steal. I've got an offer
now to make movies. Porno
movies. It's really good money, so
I think I'm going to get out for
awhile and go home.

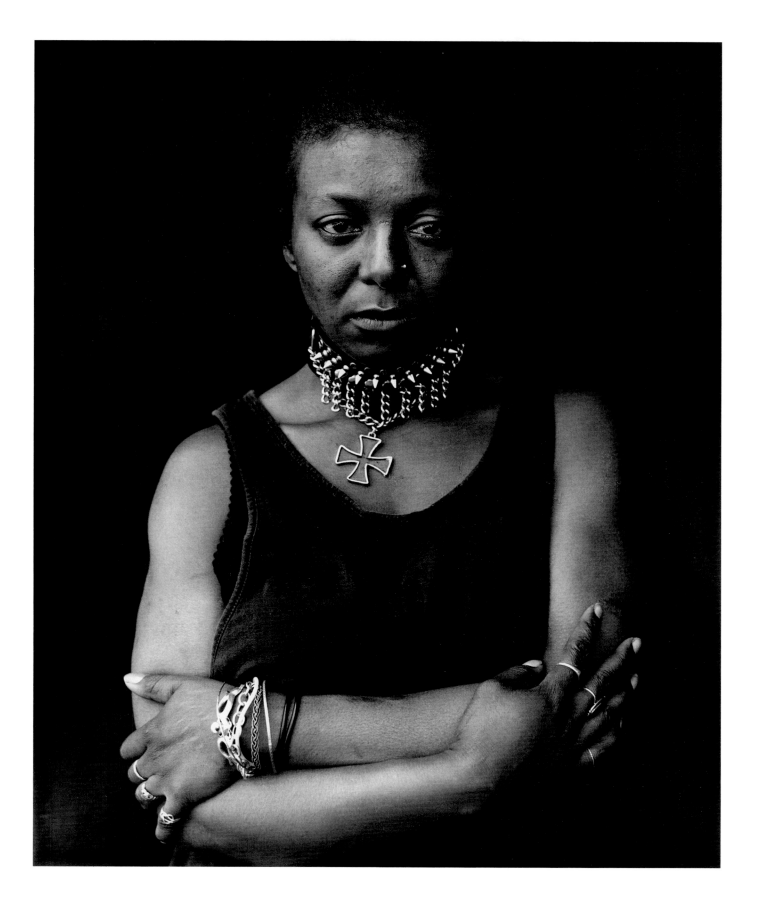

Charles Cox, 31 Macon, Georgia

I'm homeless. Lost a job back five years ago. Truck driver for Exxon. About five months now huntin' work. Ain't found nothin' yet. Can't find nothin', the unemployment rate's too high. I've got sixteen years of schoolin'. Through high school and four years of college at the University of Illinois.

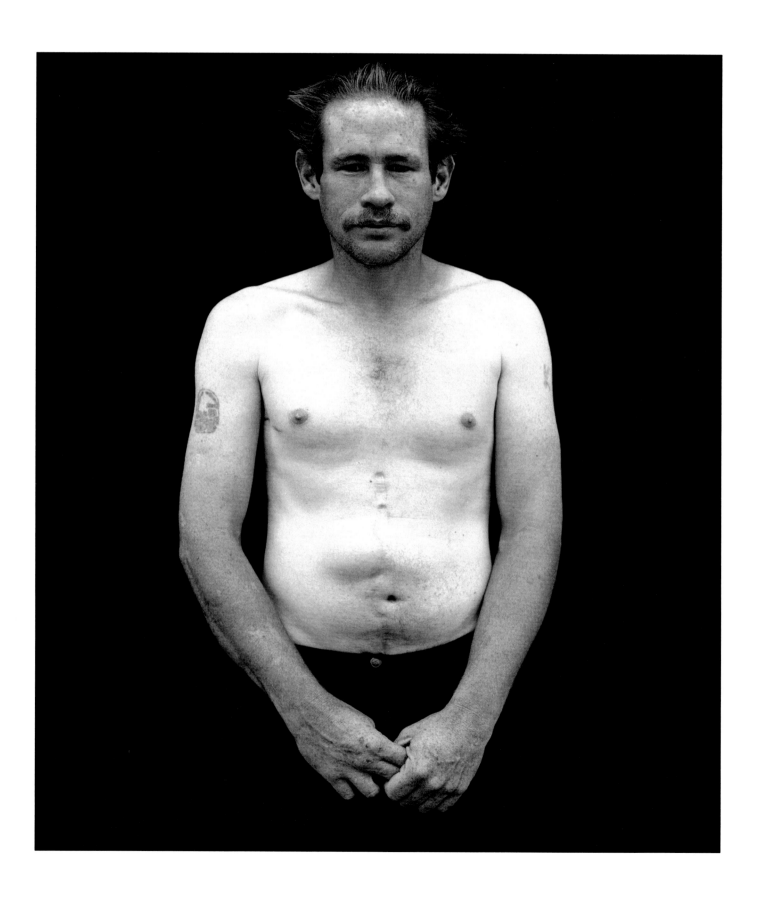

Ysmael Gonzales, 62

I've been an automobile mechanic for forty years, and then I became an alcoholic. Chronic alcoholic. I had no schooling, my father was a mechanic and he used to get drunk and come to the classroom and take me out of the classroom and say, "Well, my son don't need no schooling, I'll give him the schooling." That's why I'm pretty sharp on mechanics. I can't read or write, but I can read a motor's manual for my car. My father was an alcoholic, but I don't blame him for it. A lot of the time I'd be homeless, depressed, that's what got me started drinking. One time, I left it for two years, then I started back in again; right now, I'm not drinkin'.

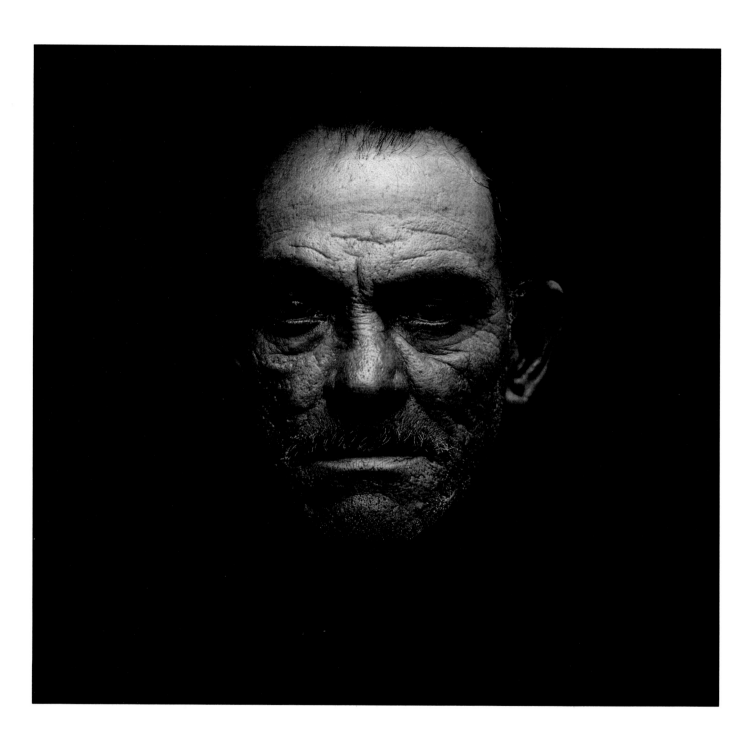

Bobby, 19

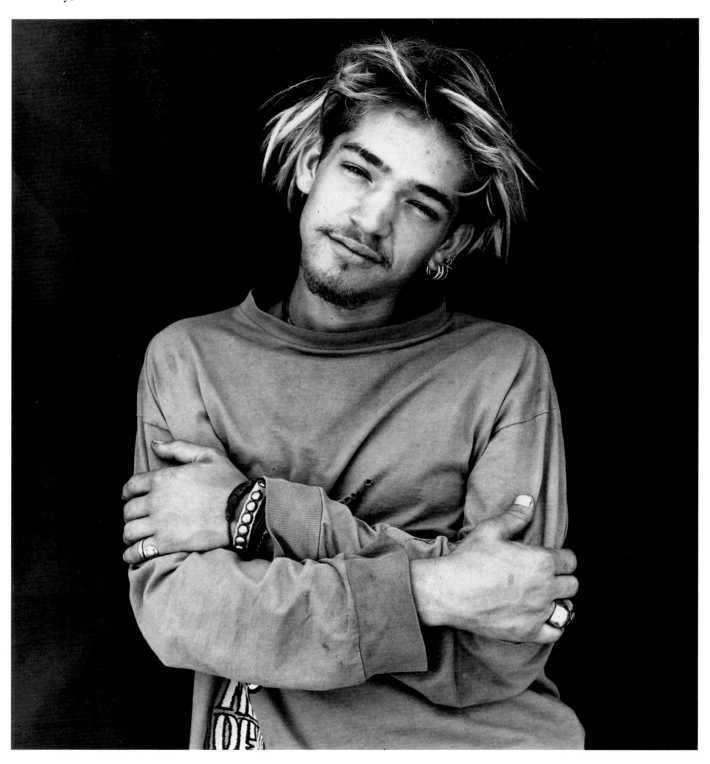

Brandi Johnson

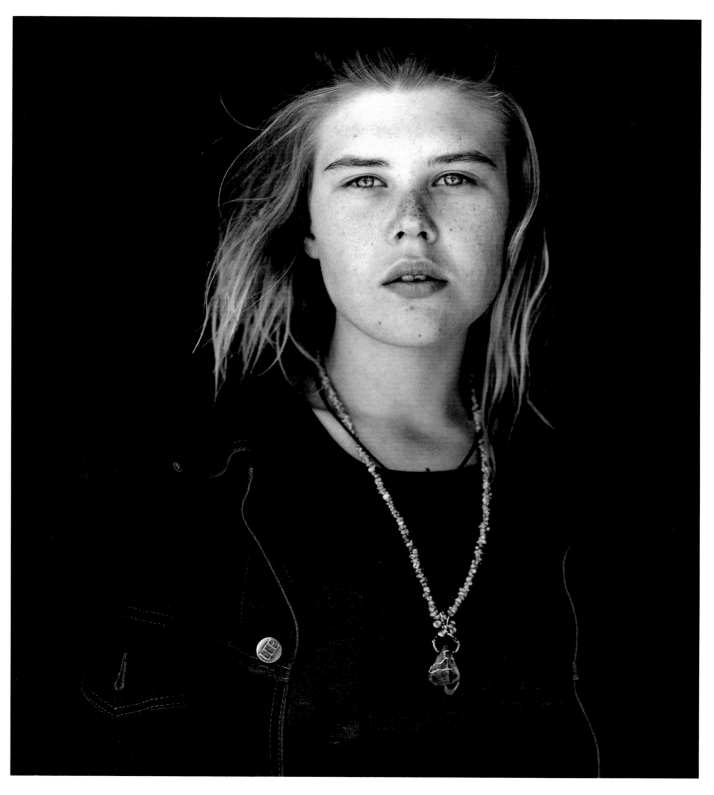

Roger Calkins, 48

I'm not a bum. I had five stores in the Bay Area in 1969. Musical instruments, retail. Roger Calkins' music company. I sold Santana his first set of equipment. Creedence Clearwater Revival, Jefferson Airplane were my first customers in 1966; Grateful Dead, my second customer in 1966. I made three or four comebacks before everybody else even got started. I shut it down. I sold three of them and closed two of them. Didn't want to do it anymore. It wasn't as good as it was. All things must pass. No one is doing what they were doing in 1971.

I've already made sixty or seventy dollars today. I beg. It's not called panhandling; it's called begging.

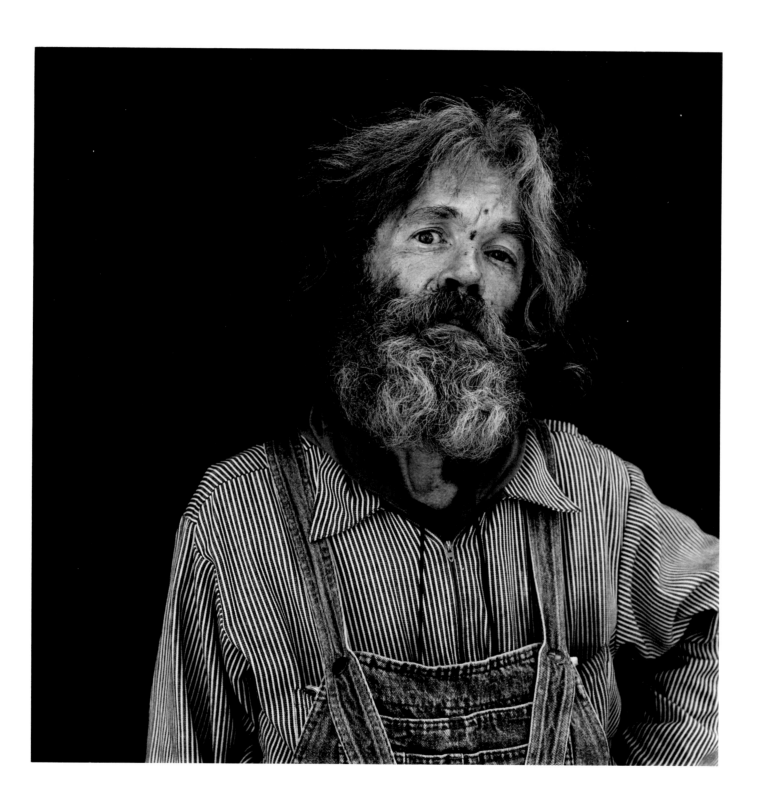

Bernice Clarkson, 37

I'm in and out of shelters. My luck just changed on me. Seemed like everything started going down, down, down; instead of things looking up for me, things started looking down for me. I was separated from my three kids 'cause I had a breakdown. I don't blame me for having a breakdown and I don't blame my kids for having a breakdown. Sometimes things just happen. I found myself wandering here and there and trying to find out what's going on: how can I get my life and my family back together again and live under the same roof again. My kids are sixteen, eleven, and ten. I want to get stable before I decide to get a job or even think about a job. I have to have a place to go to look for a job and come back and be depressed. That's the main thing, getting a place to go or get a place to leave from going to work. I have to have a place to stay first.

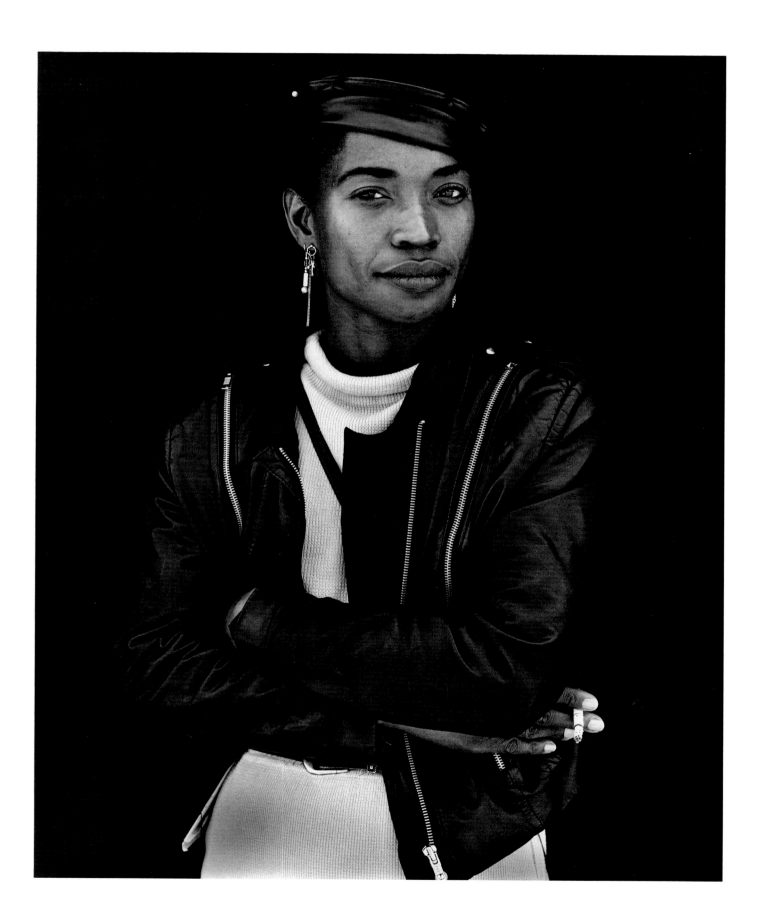

Estela Gonzales, 3 MEXICO CITY, MEXICO

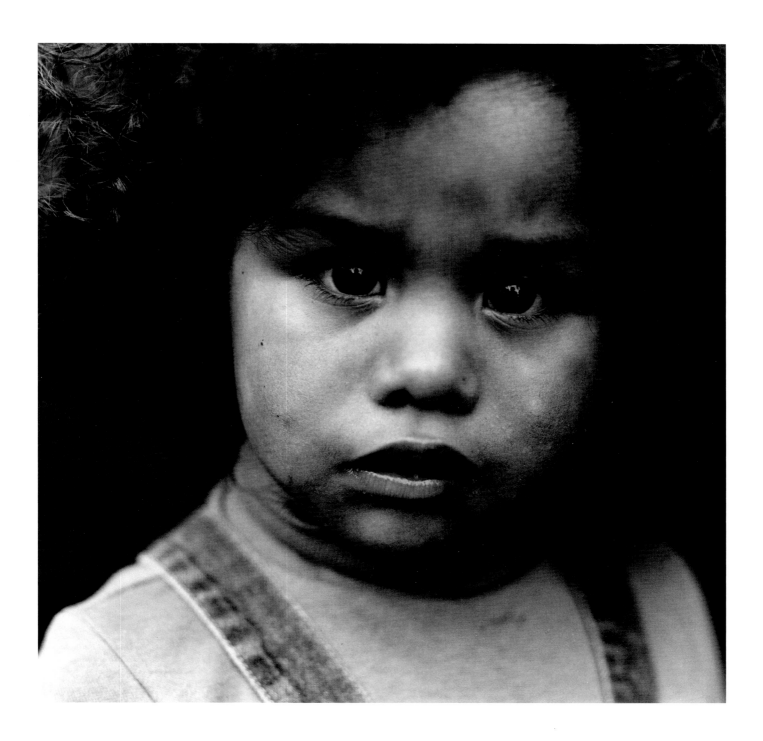

Daniel Forté, 45 TEXAS

I'm a traveling homeless victim. I have a family, about 2,000 miles away and since separation, I've been just kinda drifting from town to town, state to state and trying to do better. But it's harder to climb up than it is to slip down into this spot we're in. I came from Texas for the job in Silicon Valley. I worked there six months at $15.41 an hour. And then they put me on a termination list and the company closed. I'm waiting for them to call me back. I'll be exhausted of funds and need to get into a shelter to maintain my life. My wife is much younger than I am. She's an aerobic teacher; she ran off with a professional basketball player after I lost my business. I couldn't maintain our upper middle-class lifestyle.

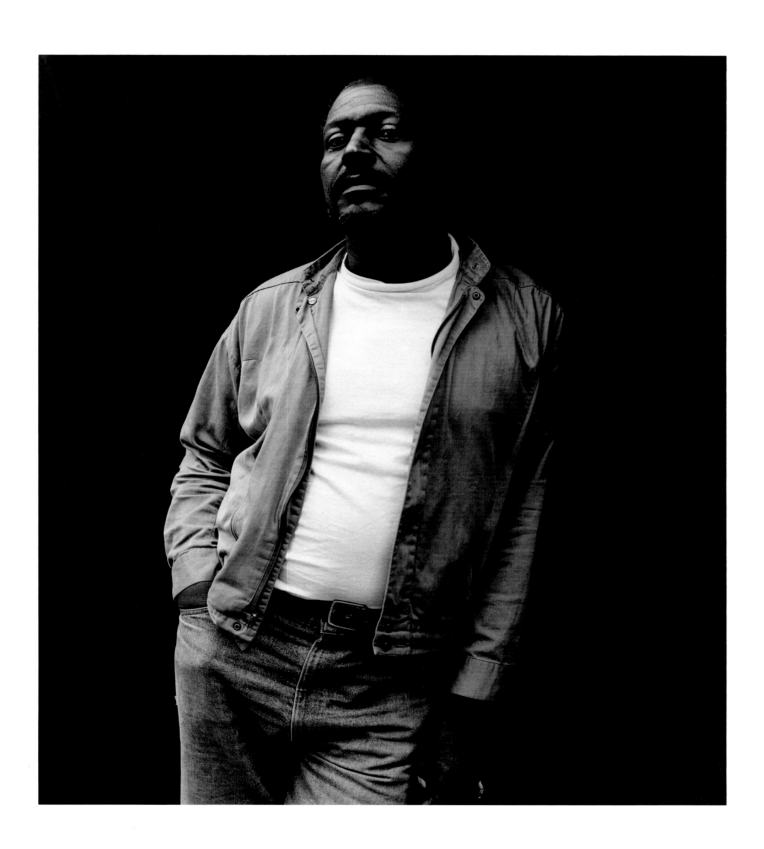

Kimberly Ann Hanson, 28 STERN, MICHIGAN

I'm an alcoholic and I like to drink. I started when I was fourteen. My stepfather had a bar downstairs and we used to steal the booze out of the basement; that's how I became an alcoholic. And I married a guy that was an alcoholic. I have eight children and one granddaughter in Stern, Michigan, with my mother. I had my first one when I was twelve years old. My baby, she's four. I've got six girls and twin boys. My boys are only five. I'm disabled. I get SSI for my kids 'cause I'm an alcoholic and I have a cracked tailbone and a bruised kidney right now, and I'm disabled. I get drunk every day. When you're an alcoholic, that's all you worry about. You're not worried about food. You're not worried about a place to stay. Last night, I passed out in a doorway. The night before I slept in a box. And I panhandle and I get what I need. I told my husband that I wanted to see the world, and he brought me out 62,000 miles. We hitchhiked. I go home once a year.

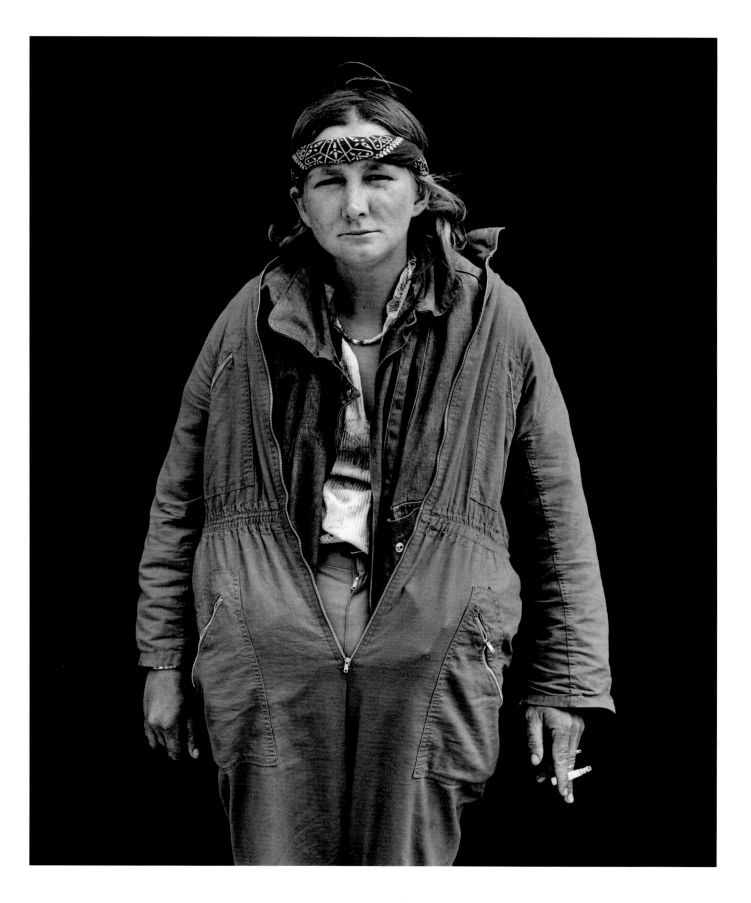

Daniel Robinson, 20 AND Stacy Cadaret, 22

Stacy: We lived in Tahoe, and a certain person was very abusive to me, and so we left that environment, and we have just been traveling from city to city. It's hard, especially being pregnant. I'm four months along, been really sick and spotting and being flat on my back. I've been having a really difficult time and I'm hardly able to eat anything. The hardest thing is not having any money to get the things done we need to have done. I love working, but I'm not able to do that, obviously. I'm a high-risk pregnancy. I've lost four before this.

Daniel: We were both living with our parents when we met in the unemployment office. We've been together five months. I'm supposed to go to General Assistance, but I want to find work. I've never been without work. I've been on the street three years on and off. The first time I was eighteen, when I left my mom's. We were kind of half thrown out and half left. I went to Santa Ana, L.A., back to Oregon, then Washington. I was a fisherman on the docks for a while. This is my first kid. I'm actually nervous. It's the first time I've traveled with someone. I've always gone by myself.

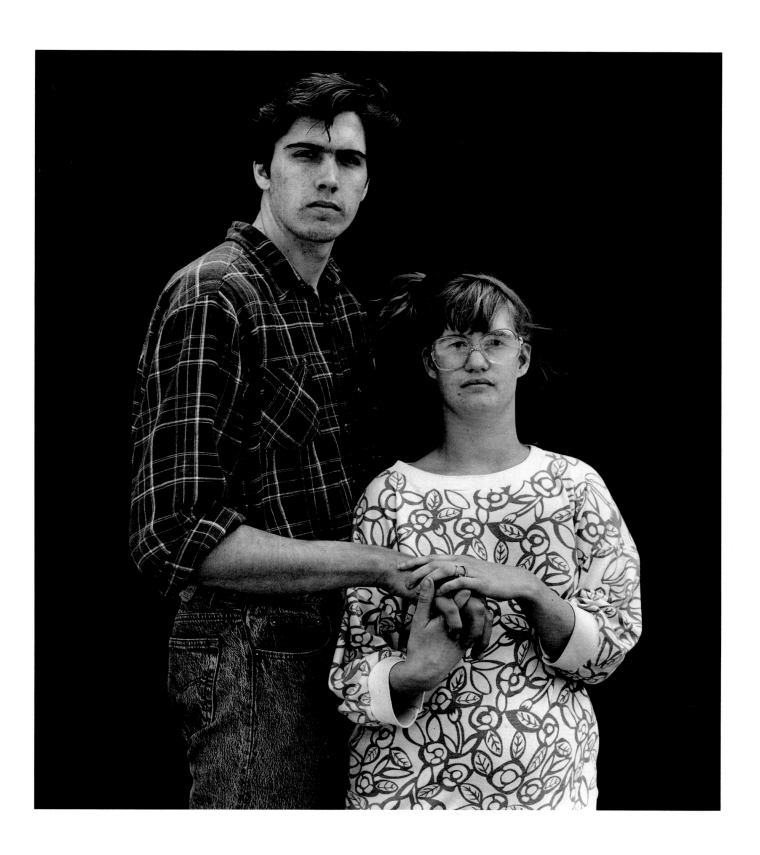

Andrea English, 40

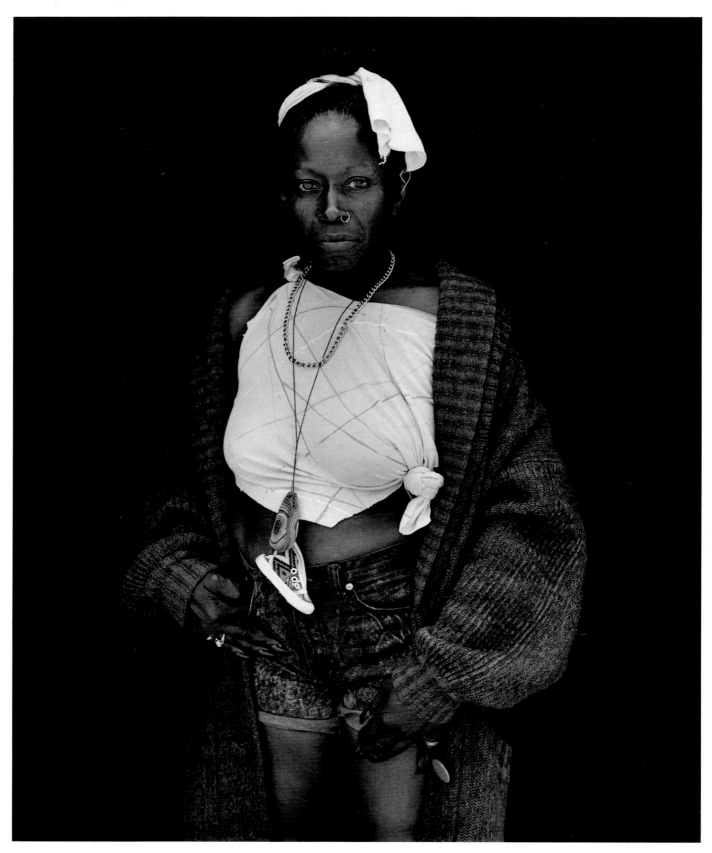

Walter Phelps

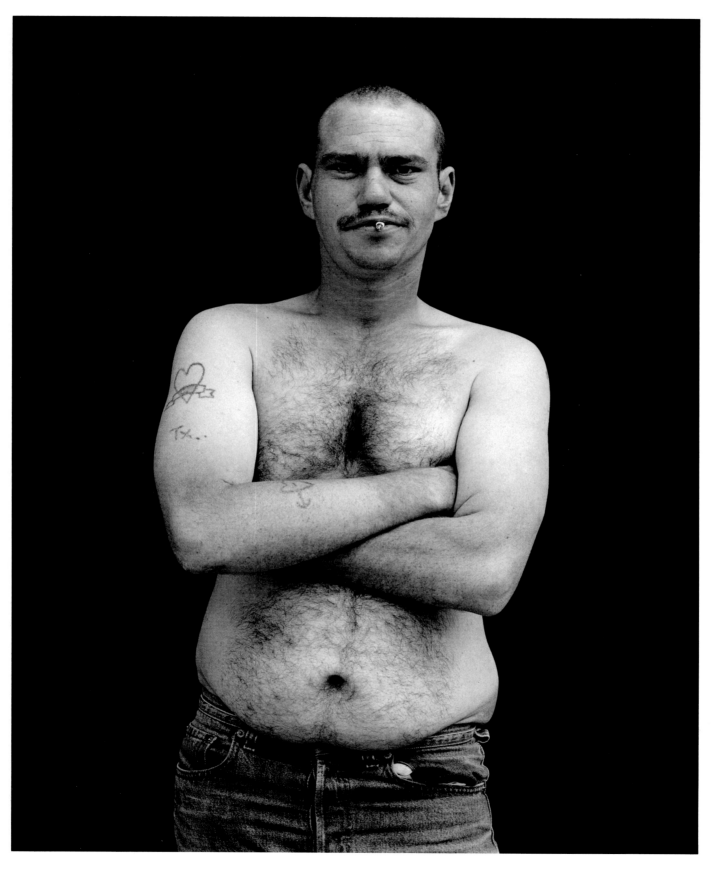

Tom Roberts Diamond, 84

Fantasy-Highlands Inn

In the body of the oak—
Ember hearts beat and crackle—
As his dream-steeped eyes—
Watch the ballet of dancing flames—
Fire steeples swirl with forgotten
* names—*

Painters—O'Shea, Watts, Koch,
* Parkhurst and Criley—*
Captured this foam-sprayed
* Monterey*
In oils and pastels—
Framed with pine cones and
* sea shells—*
Writers—Wilson, Hopper,
* Stevenson, Austin, Jeffers,*
* London, Steinbeck, Graves—*
All trod these hallowed grounds,
And with hearts and minds
Penned their love—
To this spirit-touched Sanctuary
* sublime—*

* Back at the fireside still*
* entranced—*
* I watched the fire cathedrals—*
* the flame temples—*
* Burn away the body of oak—*
* But Santa Cruz, Carmel, Point*
* Lobos, Monterey, Big Sur—*
Can never be consumed by flames—
* I toss my ember to co-mingle*
* With the other glowing hearts—*
For one unforgettable moment—
* I, too, was a part of this Carmel*
* Eden.*

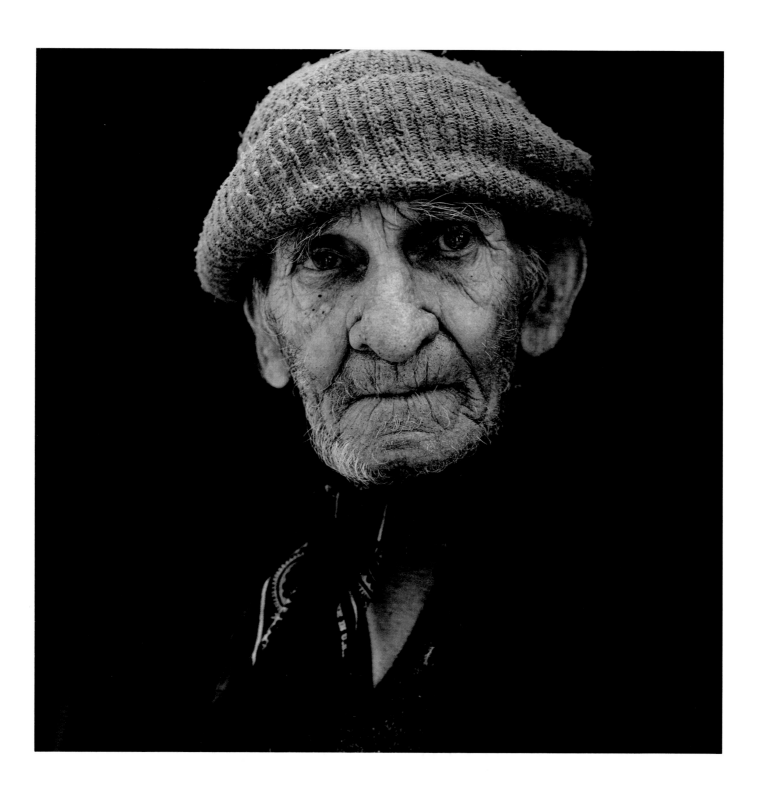

Jojo Weir, 39 CRESCENT CITY, NEVADA, AND Rosie (ON LEFT)

Jojo: We're drug addicts, look at my arms. I was molested as a child. She was molested as a child. I was married for fourteen years and had a very wealthy lifestyle. Had a Master Craft ski boat, a hot tub, a motor home—I had it all. My ex-husband is a satellite engineer. I started shooting dope at thirty-two. I was thirty-two years old when I hit the streets. I turned tricks, I turned lesbian. And I got my jaw busted. I got raped quite a few times. I got locked in a room for four days. I'm an alcoholic. I was raped by my grandfather when I was five. I tried to live the normal life, and I tried it for fourteen years, and I ended up being in a coma. I had so many pills in my body when I was married, I was in a coma and that's the last time I ever saw my kids again. And I left all the money, I left every-thing, and I hit the streets. Drugs, alcohol, trespassing, parapher-nalia. I'd never been to jail. I was a Sunday school teacher; I was a PTA member; I was a Job's Daughter; I was a Brownie leader. I don't know why it happened. I absolutely don't know why it hap-pened. Alcoholics and addicts have too much pain. We're more intense than most people. We really don't like to feel what's going on too much.

Rosie: Prostitution is not glam-orous. How sore is your mouth from sucking on all those mother fucking dicks? How tired are you from being almost killed? Tell the fucking truth.

Jojo: The bottom line is, is the worst thing about prostitution is that it's not even scary anymore. After a while, you get so shut down to emotion, and then when you love somebody, you don't even want them to touch you.

You don't want anybody touching your skin anymore. And that's the worst part of prostitution. I don't want anybody touching me. Sometimes I am afraid of AIDS, sometimes I'm not. I don't want to give it to anybody. I don't want to be obnoxious with it. But the bottom line is that you just don't give a shit sometimes. I was sodomized by my grandfather for years. For four years. From ages five through nine. It just hap-pened. Nobody was paying attention.

They don't never pick you up, Rose. They don't never pick you up. They pick me up left and right. It's because I don't have a harsh voice, and I'm sweeter, and they think I'm more vulnerable. They don't know that I'm the bumble bee and she's the wuss. See, she looks like the big type, but I'm the fighter. We've been together eight years. I'm real angry. Quietly angry. Because the worst thing you can do to a child. . . .

Rosie: Joanne, you speak so softly. . . .

Jojo: See, my anger is very calm.

Rosie: You don't want to cut his dick off and stick it in his mother fuckin' mouth?

Jojo: My anger is very calm.

Rosie: Jump up and down on his grave?

Jojo: No, my anger is very calm.

Rosie: Well, you don't have any anger. Okay? You're in denial.

Jojo: My anger is so calm, see, I'm real mellow. My anger boils beyond her loudness. My child-hood was taken away from me. The little girl in here is gone. She's gone. She's gone. And I tried to live life like everybody else wanted me to, and I couldn't do it. They took the most pre-cious thing you can have, and that's your childhood. But the thing is that I'm not getting back at them, I'm getting back at me. And I know that. Every day I kill myself. I've OD'd, I've been in comas, and I can't even tell you how many times I've been in the hospital.

You know, I just keep trying, trying, and trying, but there's some part of my soul that keeps me wanting to stay alive. You know, my heart is as big as the Grand Canyon. Life is a race, and it doesn't matter who finishes first. It just matters that you keep trying, you keep trying to win that race. And I keep falling down, keep getting back up and putting on those Nikes, and keep trying to win that race. And that's harder on me than it is on any-body else. Because it doesn't have to do with anybody else. But I try real hard to win that race. Doesn't matter if you come in 307. The bottom line of the race is you just keep going. Who cares about the blue ribbon?

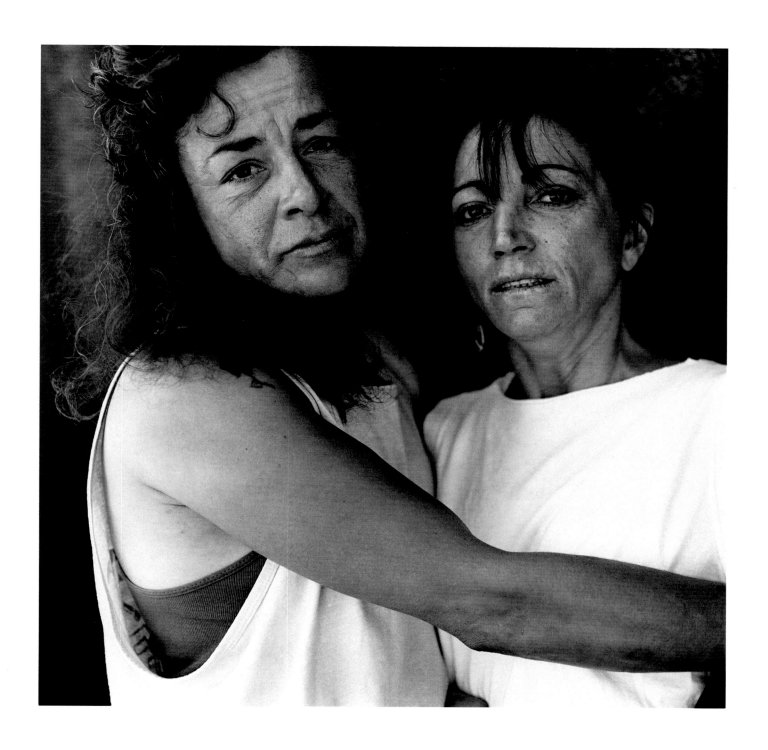

Steve Green

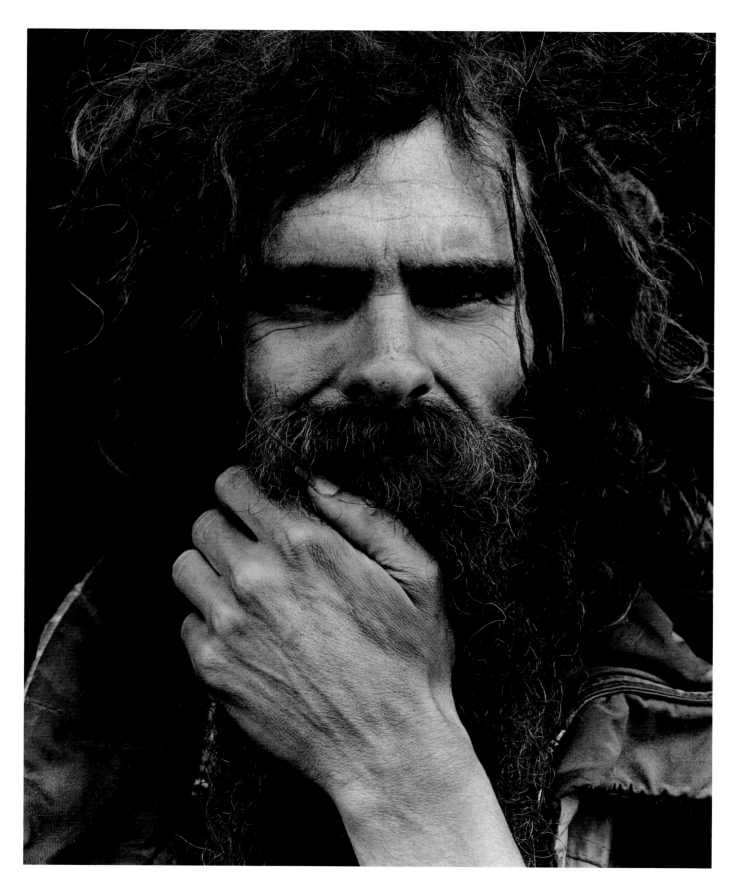

Michael Levine, 18 AND Chris Nullis, 19

Chris: I break into an abandoned building; it's condemned or nobody needs it, so therefore I'm gonna just sleep in it. Housing is a right, not a privilege, therefore, when you have an empty building, it's shelter from the rain and the wind. They say we can't do it, but fuck 'em. I'm gonna do it anyway.

Mike: Sometimes I've gone to jail, but most of the time, the manager or the owner, they just say, "Leave and don't come back." Sometimes they're really cool about it, and sometimes they're total dicks.

Chris: I've been doing this six years now, ever since I got kicked out of home. For drugs. My parents never respected me for who I was. So I left.

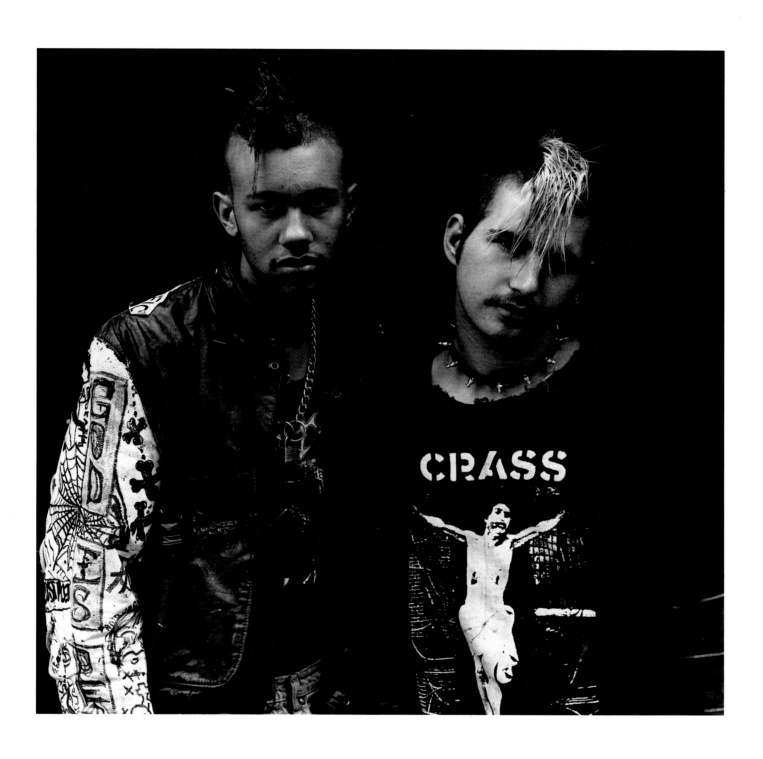

Thomas McMullen, 26 EAST ST. LOUIS, MISSOURI

I just got out of jail for robbery, burglary. I was in for twenty-six months. My family deserted me when I was fifteen. My mother and father were divorced. My mother couldn't afford to take care of me no more, so she put me out when I was fifteen. Got with my boys, got in gangs. They became my family, just started kickin' in like that. We were stealing cars. I got caught and my friend got away. He went home. I had to do time. Prison was a war zone. We gang-bang, fight, lift weights. We lock up when the man tells us to lock up. Eat when he tells us to eat. That's it. You sit in there. You work out. You eat. You wish you be out.

There are not a lot of opportunities out there for you. If you got an X on your back, plus you're a black man, you know, it don't really work in your favor. People are scared to hire you 'cause of what you might do. In prison they'll give you a job working in the kitchen, or they'll give you a job working maintenance. They'll give you a job doing this, but once you get out, what are you gonna do? Put on your résumé, "I learned this at San Quentin?" Then they wonder why you come out and so many people go right back. I don't want to go back to prison. I ain't even been out a week. I've been walking around, filling out applications, going to see my parole officer. Trying to keep from getting too frustrated.

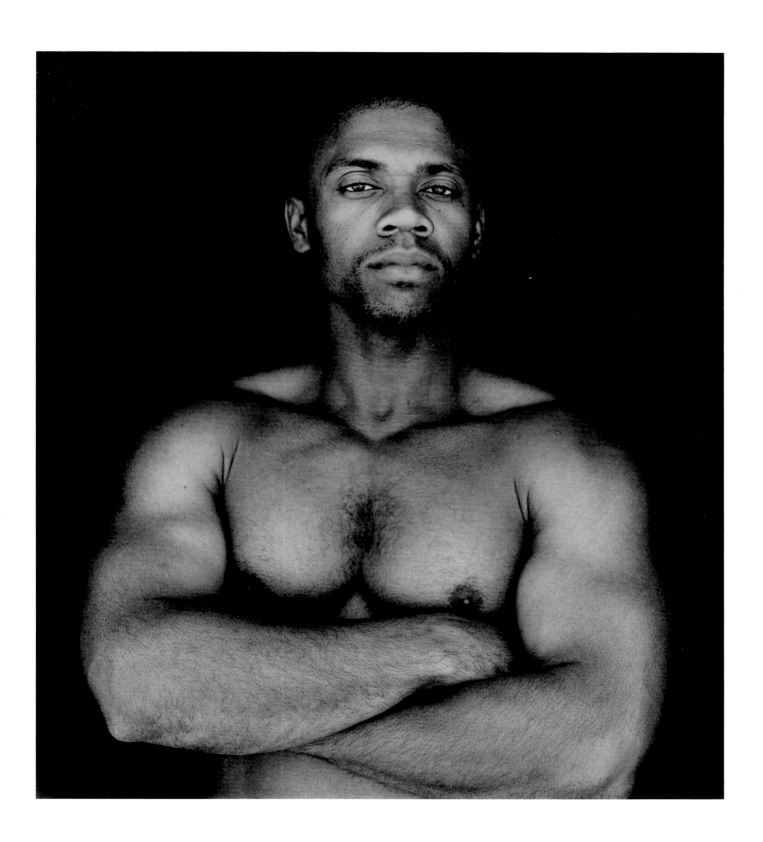

Michelle Brown, 30

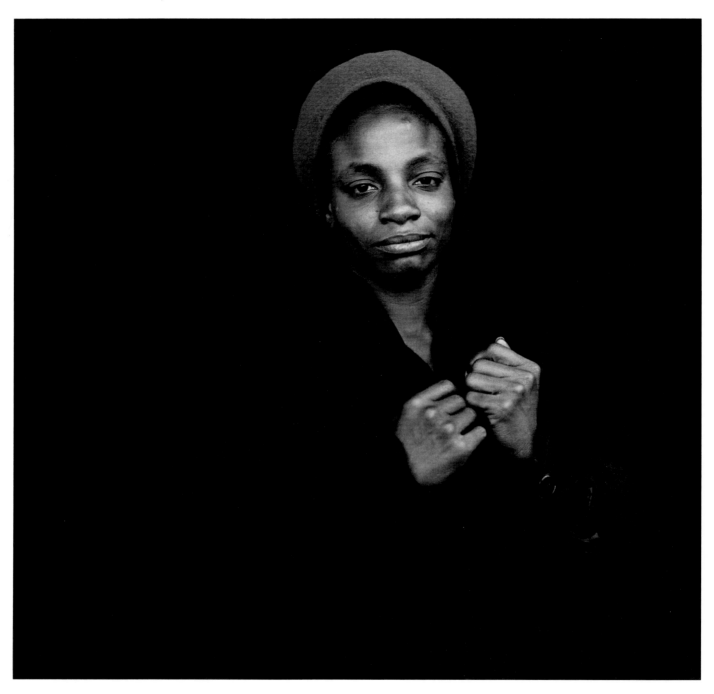

Rick Lucas, 31 RICHMOND, CALIFORNIA

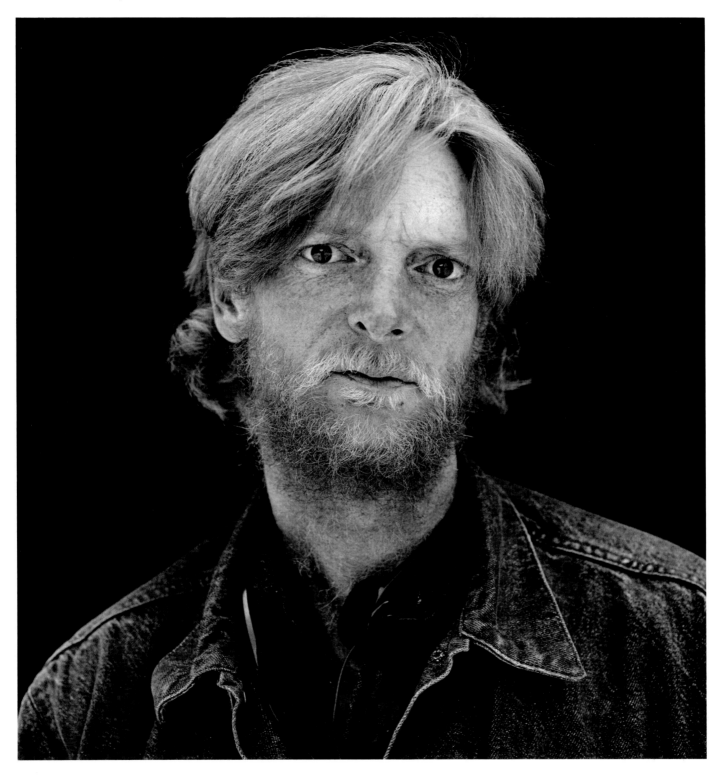

Paul Maituza NEW YORK, NEW YORK, AND John-John WASHINGTON

Paul: I'd like to be sitting in front of the TV watching Bugs Bunny, you know, smoking a joint and having a cold beer. But I can't do that. I collect bottles and cans. I'm an alcoholic. If you really get it in your mind to get off the streets, they'll put you up for thirty days while you go look for a job and all that. I have no work record. I haven't had a job in, Jesus, six years. So they say, "Well, what's your last employer?"

John-John: I've been in the state penitentiary twice. And I've been in a state mental institution. For stealing a beer truck. It was ten o'clock in the morning and they started making deliveries. I was going to have me a whole shit-load of beer. I always have a smile on my face. I walk around and see these working stiffs, they all got frowns on their face. Man—oh, man, I gotta go to work. And shit, I'm out of all that.

Paul: Actually, it's nice not having any responsibility at all. You know. I mean I can go where I want to. If I feel like going to San Diego right now, all I have to do is stick my thumb out. I got no ties, no nothing. That's pretty good.

John-John: I started drinking when I was eight. I used to get one of my dad's coats, with sleeves that were real long, past my hands, and go in and grab. And I'd just slip up the sleeve two bottles of vermouth in each one and walk out. And me and my partner would go drink a couple of bottles of vermouth and get shit-flying drunk. My dad died of cirrhosis of the liver at the age of fifty-six. But I never met him. He screwed my mom and left. I ran away when I was twelve years old. I lived in the park. And I used to break into trucks and steal cases and cartons of cigarettes. And cases of great big Hershey candy bars. I used to sell the candy bars for a quarter a pop. And I used to sell the carton of cigarettes for a buck.

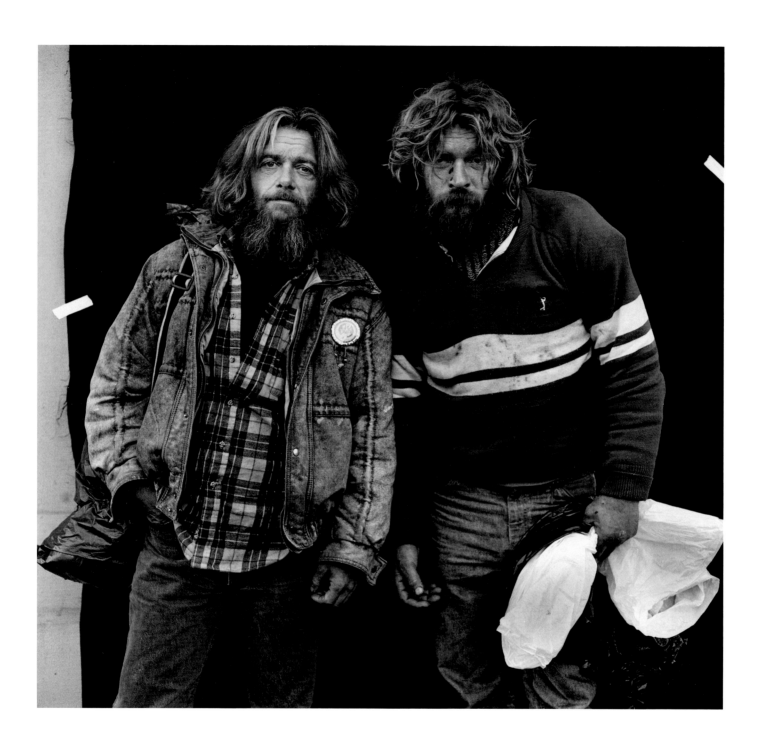

Walt Sidney, 25

I was born in the summer of love, and I was one of the seeds that was planted. Finally come to fruition, perhaps. And perhaps there will be a renaissance of spirit again. They say the bus was cranked, everybody got aboard, we got the thing up to light warp speed, and then even before they left the driveway, they paused to stop to see which way to take the damn thing and slammed themselves in the ass and that was the end of that. So, we now hope to get this extraterrestrial crap cranked up again and we think we have a direction. I bet it would be Disney's World and Braziland, or restore Vietnamland and Cambodialand to their pristine purity, owned and operated by the entire Mickey Mouse Club of Humanity. We're truly a club made for you and me, with fair shares all the way down the line, one world corporate family. Create a greater good for the greater whole, and you are welcome to the real rewards of the world.

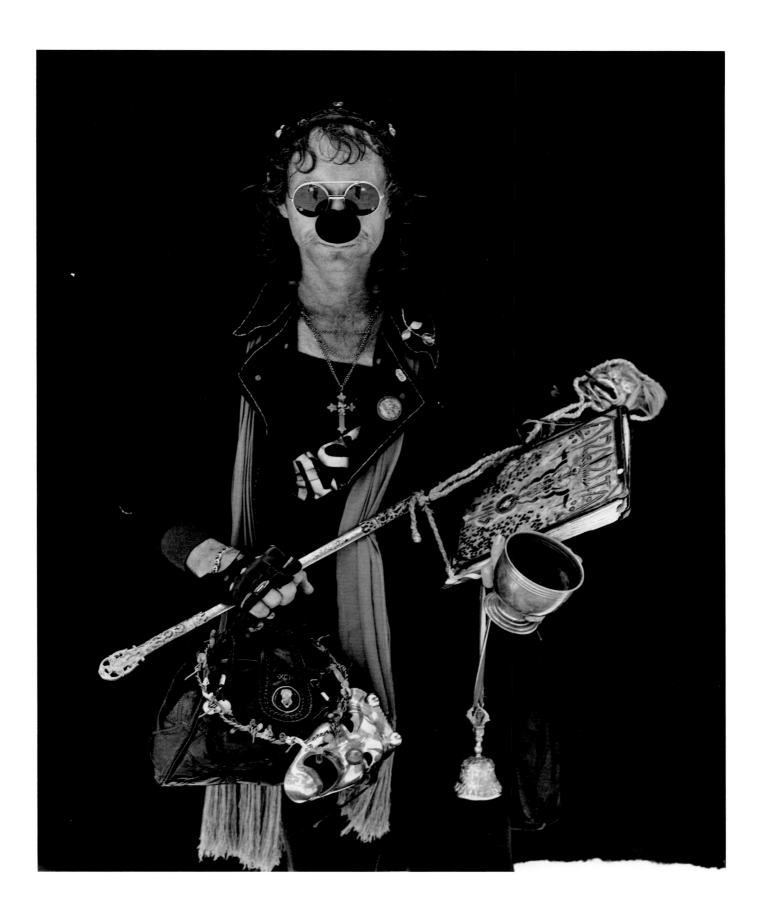

Charles Morgan, 42 AND Sheila Smith, 22

Charles: We've been together six years, and we've got three kids together.

Sheila: Jack is four, Christopher is three and a half, and Jeremy is eleven months.

Charles: Her mother's a bitch. She don't like her. Let's put it like this: if we, me and her, had nowhere to go, and we showed up on her mom's doorstep, she wouldn't let us sleep in a sleeping bag on the back porch outside. My mom, we show up, she gives us a place. She lets us go in and take a shower. I drove trucks for nine years. Drove taxi for five years. I got a drug charge on me, so now I can't drive a truck or a taxi. I got a heroin charge. I was busted with a rig full of coke. They busted me with a few rock pipes. I did 254 days last year in jail.

Sheila: I've also done quite a bit of time in jail, because of my prostitution to support my drug habit. I do heroin, I do rock, I do weed whenever I can.

Charles: She's high on heroin right now. We did rock all night last night, so we had to have something to get calmed down.

Sheila: Rock cocaine.

Charles: Rock is the worst drug that man ever made. Because it's a mind-altering drug. You don't have any control over yourself. I got her off of it, though. Every once in a while, I'll let her smoke a little bit, but here, lately, I've been trying to keep her away from it. And she's not hooked on nothing now. Other than the fact she can't stand reality, and she likes to get high.

Sheila: We have nothing else to do besides come out here, stand around, and panhandle. We never steal for the money. We always make the money. Somehow. If I have to prostitute for it; if I have to sell something. I've been in jail from the time I was eighteen until now, I've got like eleven or twelve prostitution cases.

Charles: We're trying to straighten out. She got into a drug program. She's going to go tomorrow at noon. Try to get herself clean.

Sheila: I sold everything. TV. VCR. Microwave. Clothes that my kids had, the beds, I mean I sold everything. I've been using drugs since I was fourteen. One of my girlfriends said, "Come on, come on, it's good. It's good. Come on, try it, just try it once." That was crack. I tried it and couldn't ever stop from that time on. I been shooting quite a bit of heroin. I got needle marks. I moved in with him at fifteen.

Charles: She was doing drugs with her brother before I met her.

Sheila: We have our fights. We do have fights that are caused from the rock, from the heroin, and from doing the prostitution. Because, you know, he's my old man, and I'm his old lady; he feels like I shouldn't be out there. . . .

Charles: She's my property. That's the way I look at it.

Sheila: . . . selling my ass to somebody else when it should be only his. We have to support our habit. It's the easiest money I've made, ever. What I do is I walk up and down the street. And guys walk up and say, "Do you date?" And if I say, "yeah," then I make at least fifty. And that's only for intercourse. For the hand jobs, I charge twenty-five. For some head, I charge anywhere between seventy-five and one hundred and fifty for that, because I don't like it.

Charlie: But she don't make love with none of them. She just fucks them.

Sheila: Five or ten minutes. And if they want thirty minutes, it's two hundred. If they want an all night, it's six hundred right off the bat. It's scary because you don't know if the guy has a gun. You don't know nothing about this guy. If he's got AIDS or nothing. I always use a rubber. I'm not his friend. I'm just a woman out here.

Charles: The all-mighty dollar is her friend.

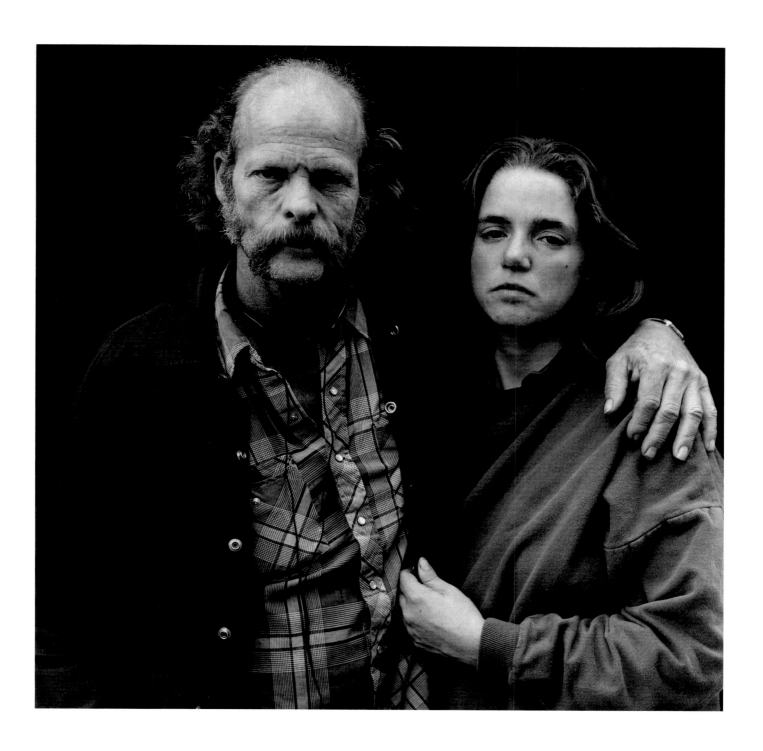

Daniel Crow, 20

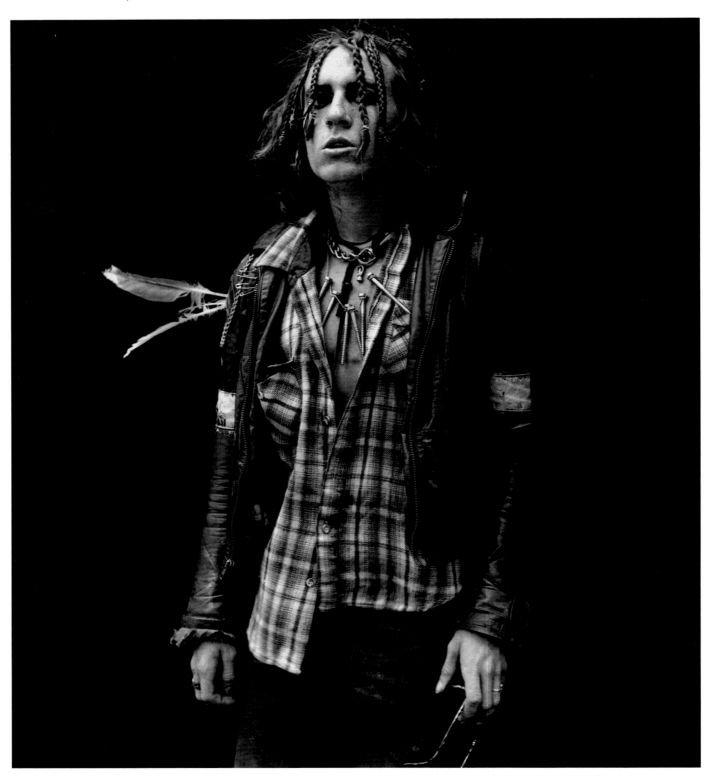

Sapphire Whittaker

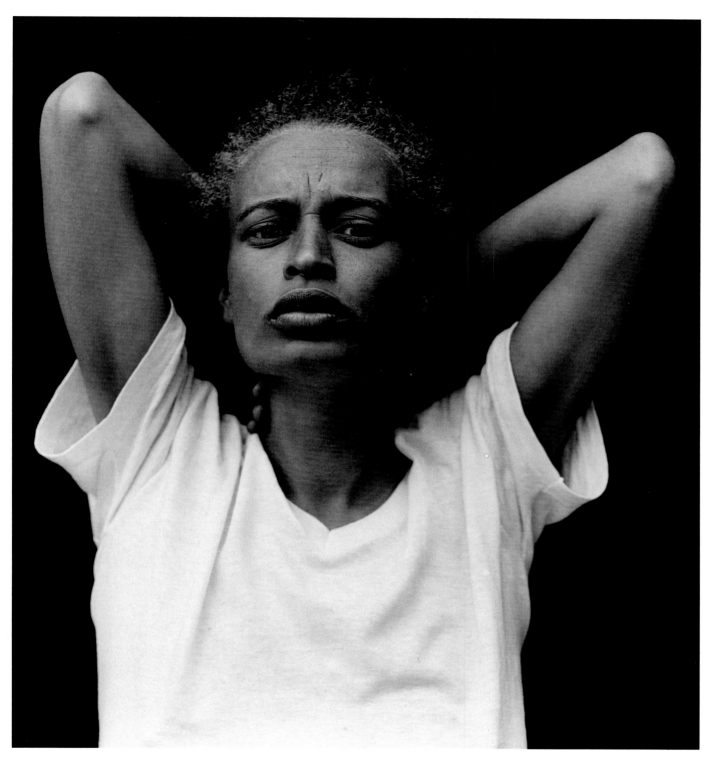

Edward Hazen, 41 TENNESSEE

I've been everywhere. I've been all around. I'm a tramp. A street person. Usually. But sometimes I work at the Salvation Army or different places. I'm homeless, and I'm a chronic alcoholic. And I've been drinking very heavily and so I've miscalculated a lot of things, and so I'm homeless. I was drinking so much that I just forgot a lot of things. I was working. I was loading trucks. I had a good job and that was about three months ago. And I just got drunk and see, it gets worse all the time. It's progressive. So, here I am. I just hope I can get myself together. That's what I intend to do, but it's not that easy. I started drinking when I was twelve; I'm forty-one now. I've been homeless before, but it wasn't because I wanted to be homeless. But this time, it's harder to get back. I don't want to be homeless. I've been homeless once before but it was because I didn't mind it. But I mind it now, you know. I'm getting to the point that I'm making too many mistakes. I got robbed the other night. I had some money on me. It wasn't much, $15 or $20 is all I had on me in cash and then I had a pack of cigarettes, but I had a blanket and that was warm. I woke up the next morning and didn't have nothing.

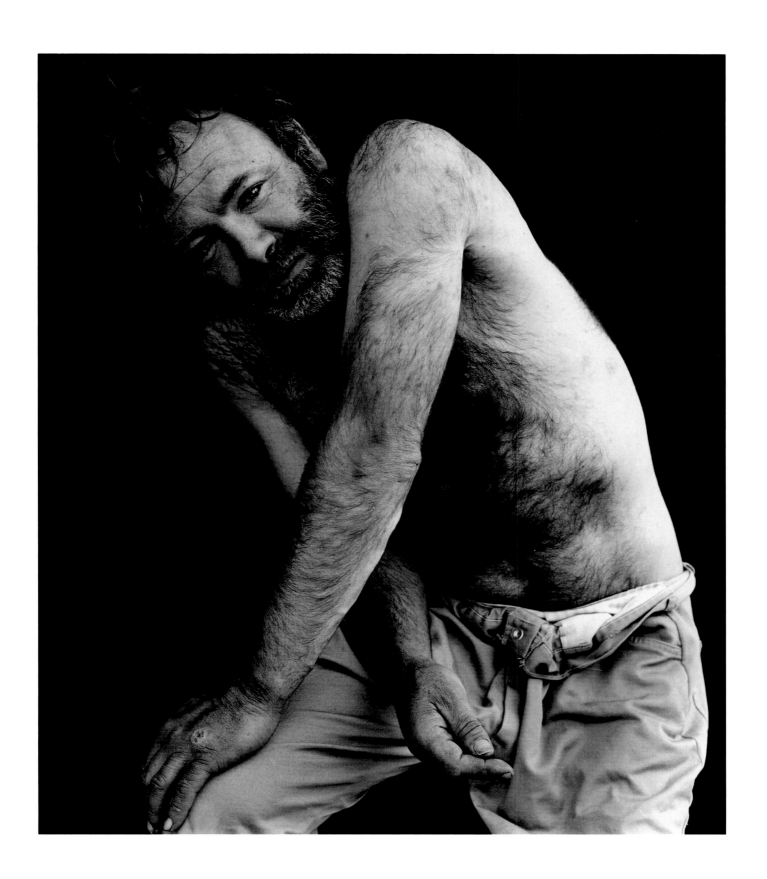

Sarah Smith, 25 SAN ANTONIO, TEXAS

I was born on the day that Mt. Vesuvius erupted on Pompeii. I'm a Leo-Virgo. Went to college for a little while. Got married at eighteen. Divorced at eighteen and a half. Once I got divorced, I couldn't afford to live on my own, so I started working as a call girl. It was kind of neat. I traveled all over the world. I met diplomats, movie stars, people who have been on "60 Minutes." Flew in private jets. I looked a little different then. I had long blonde hair. I made a lot of money, and it was real exciting.

Somewhere down the line, things just changed. I guess my drug addiction would probably be what stands in the way of me accomplishing anything. I'm intelligent. I just have problems dealing with life. See this bag of clothing? I'm selling my clothes that were left over from the days when I had lots of money. Been a drug addict since I was about thirteen years old. Now my battle is with heroin. I inject in my neck. On my hands. I don't have much left in my arms. I don't eat a lot. I smoke crack. It takes away your appetite. I don't share needles. I've been tested many times. I'm very fortunate. Most heroin addicts don't really have an active sex life 'cause heroin becomes your lover. And when I did work as a call girl, I was very, very, very careful. I was paid between $300 an hour up to $1,000–$2,000 a night. So, at that level you're dealing with people that are much different. Not to say that they can't be with AIDS.

The world's changing, and some of us still have real qualities, which are honesty and love and some kindness and genuine care for people. I lost a lot of friends lately. Just in the past seven or eight months, I've had five friends die. Four of them were suicides, one was an overdose. The only thing that I really, really want out of life is to know true happiness and to have a child.

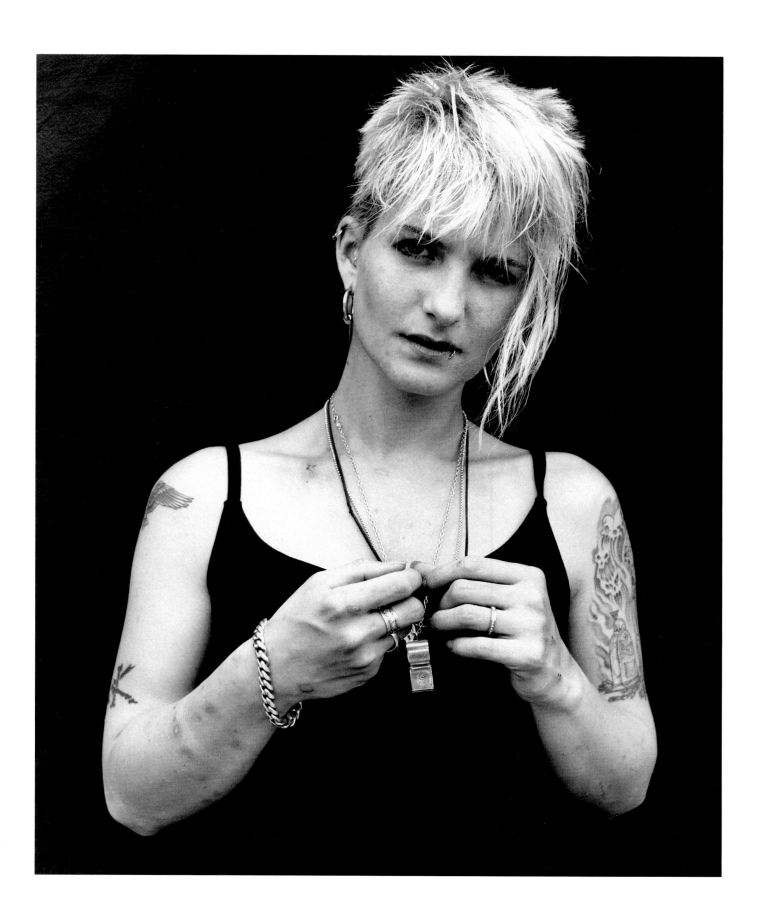

Albert Trumbo, Jr., 42 MORINS, IOWA

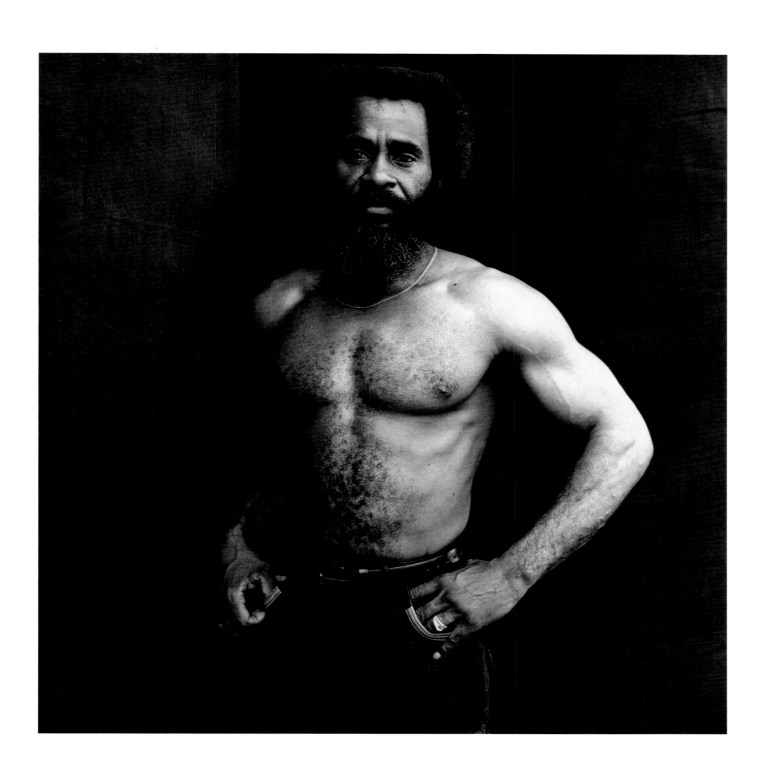

Michael Stoffel, 35 CLOVIS, CALIFORNIA

I've been up in the woodlands forest territory and without people for a while, so I'm down for a little fun and games. There's a lot of basic freedom and you can be unburdened by imposed pressures, you might say, vultures of society. Most society is based on advertising and conditioning people to act in a certain manner, a certain way, and to a point where they would even get violent. In my case, if you don't act accordingly and be a good consumer and employee of the system at large, I really had a lot of problems with forced taxation out of my check when I found it was really inappropriate use of taxes that were being taken, I found myself actually morally responsible for what they were doing with the money. So, I couldn't work under the taxable situation. Mostly, I actually need very little. I go real slow, very, very moderate lifestyle. So, it's really pretty easy.

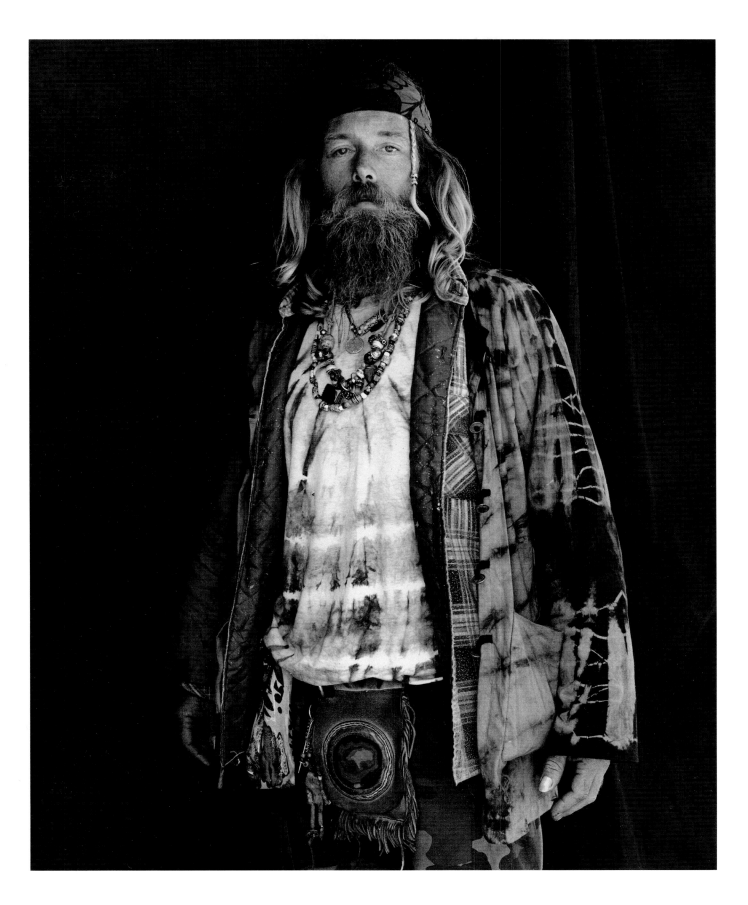

Penny Rodriguez, 18 SAN FRANCISCO, CALIFORNIA

I live in the park. I try to get places to stay. I hustle. I try to stay alive. I get things and sell them for a higher price. Weed, crack, little dresses; I go in shops and steal, and I sell it for a lower price. I've been living like this for about three years. I was abused. All through my life. It still happens now. My parents are well off in money, but they're not well off in the brain. My parents are separated; my mom, her main concern is herself. And my father, it's the same thing; he wants his needs met, and they don't need to have a child. I stayed with my boyfriend, hustled, and did a lot of things I regret. I slept around. I wasn't really a hooker but I was a hooker. I didn't get paid, but I got paid in clothes and jewelry. I smoke weed. I like that. I'm pregnant, so I'm not supposed to. I try to stay off that, but it's so hard, you know, and I really don't have anything to get rid of the cramps I get. I'm going to have the baby, and I'm going back to school.

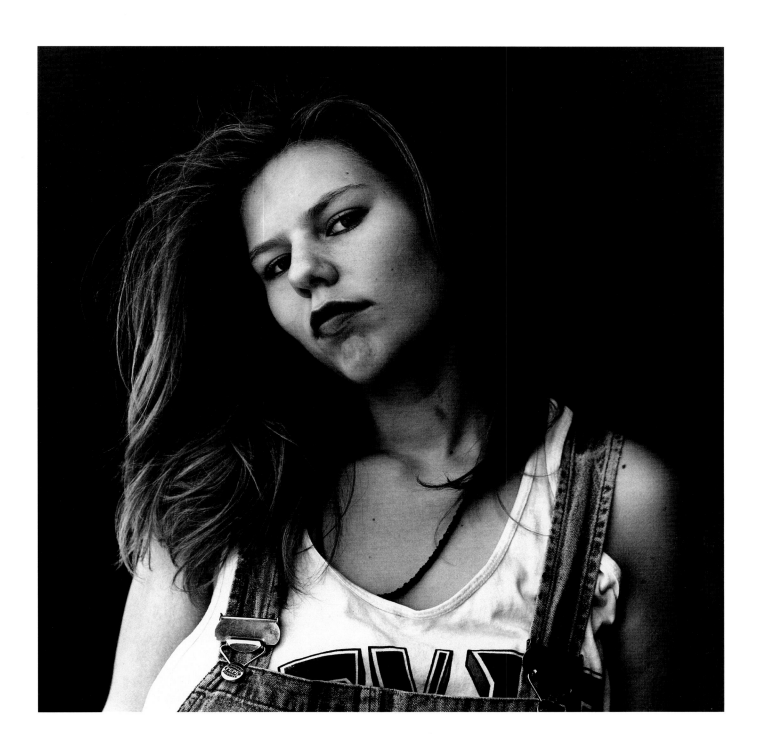

John Maupin, 30 OHIO

Homeless isn't so bad, really. There's plenty in the city for people. There's lots of places to eat. You can't really go hungry. There are places where you can get a shower, and friends will help you out. Depends on how you present yourself. I was doing speed for a long time. I've been doing a lot more heroin now. They have that needle exchange. It's pretty well all set up for anything. Homeless or not. Depending on how you want to keep yourself, you can do fine, really.

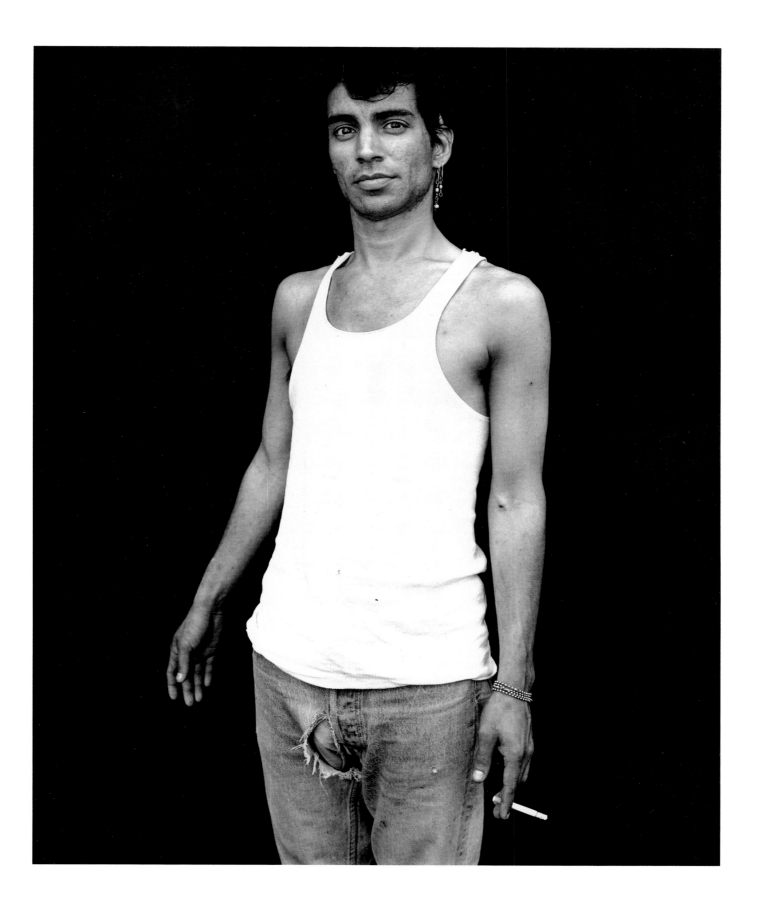

Florence Rice, 65

I do open court casework for the U.S. Supreme being out here. I'll be working on some for the Bay. And airlines safety. When the airlines come through sometimes they crash. We have to be sure they don't hit the buildings, or hit each other. On these buildings, I wasn't allowed in, and some other people connected with me. The Supreme Court ruled we were supposed to go in, and they put some other people in. The plan was that we were supposed to go in and they put the other people and they've been taking all the money out, and we were supposed to get our funds here. And housing and food. We didn't get it. I was declared the owner of this building by the Supreme Court judge. But some people thought it was they. They themselves instead of me. I just work here during the day. It's too dangerous here at night. I stay around security, some strict security, because this area got too dangerous. You know, if you read in the paper how dangerous it is around here. Also, my job is feeding wildlife. The U.S. Senate's given me that job. The wildlife need feeding because a lot of people don't want to bother. Some get checks and they don't want to feed the wildlife. They put me on that job from back east, the New York judges, from Washington, D.C.

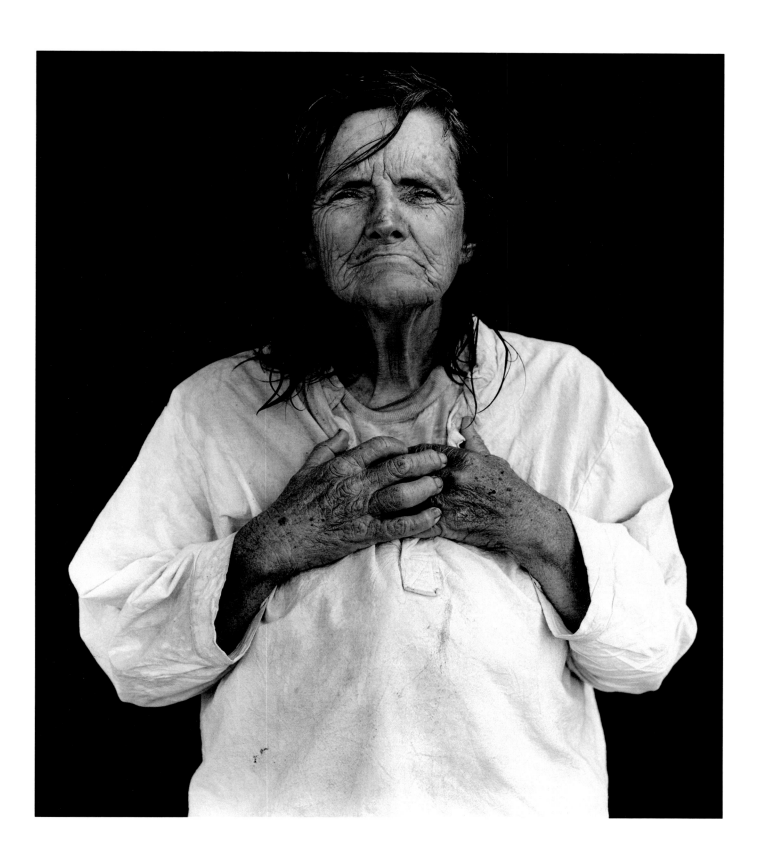

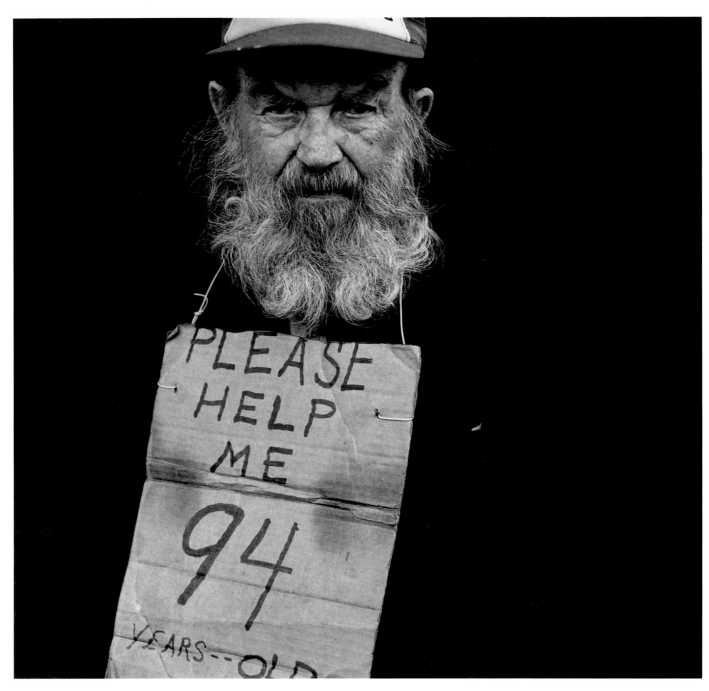

Edward Zuniga, 57 SANTA BARBARA, CALIFORNIA

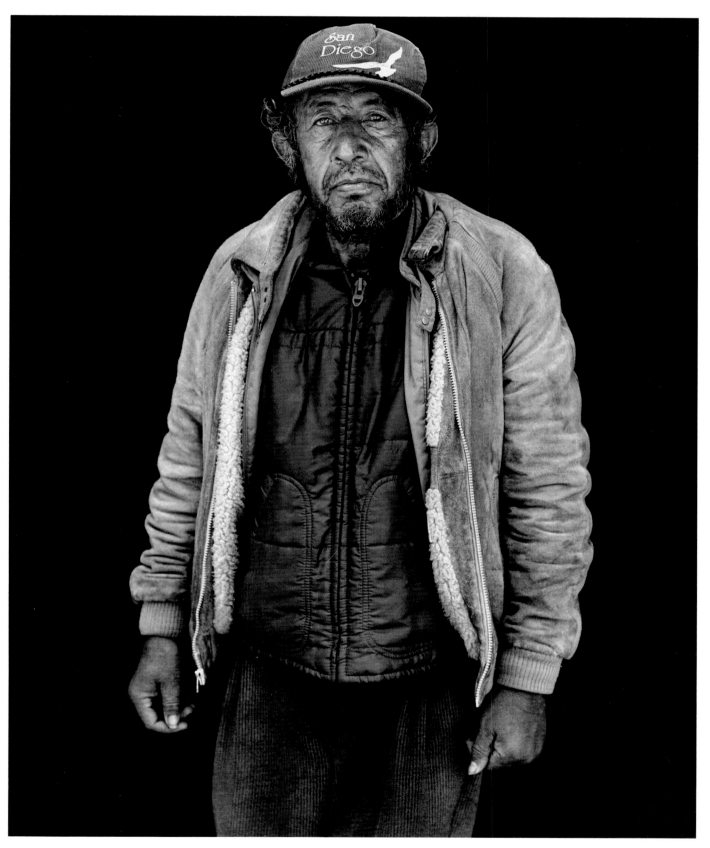

Linda Broussard, 37 AND SON

I walk out here and see all this
shit: somebody's selling dope
here, making their fast money,
and then that thought click in my
head, "Maybe you should make
fast money," but then I have two
kids to look out for. I can't take
the chance. I'm just struggling.
How the fuck am I supposed
to survive? Ten years ago I was
nursing. I got a master's in regis-
tered nursing. I hurt my back and
I was on Workman's Comp, and
then I ended up pregnant with
my daughter. As soon as she got
old enough to go to school, and
where I could put her in a day
care after school, I pop up with
my son. Hell, I can't win for
losing. If it wasn't for bad luck,
I wouldn't have no luck at all.

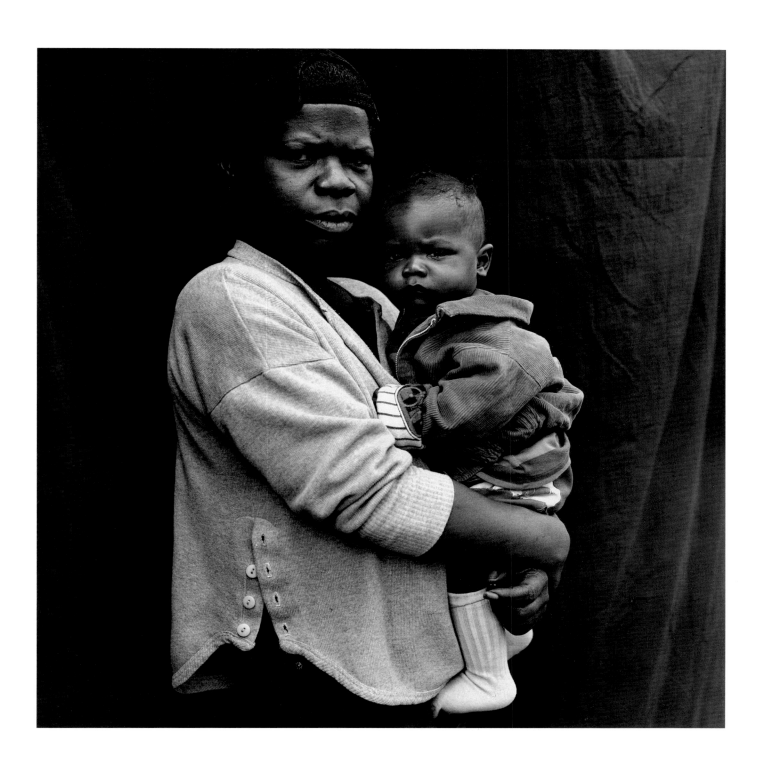

Eric K. (Blacky) von Richter, 53 MUNICH, GERMANY

I come over here when I was a kid, went into the Army when I got old enough and, after I got out of the army, I decided I'll go to San Francisco. I got here in '66. I knew almost everybody that became famous: Janis, Jimi Hendrix, Grace Slick, Jim Morrison, Big Brother and the Holding Company. I remember when the Grateful Dead were called the Warlocks and they had free concerts in Golden Gate Park on Sunday. I had a bus. I used to fill my bus with people and take it to Speedway Meadows or Marks Meadow where the concert was going on. We'd stay there all day, and I had a big flag that I would stick in the ground. The purpose of the flag was that if you got too stoned you could find your way back. There's a lot of the old people still on the street. I look at them and say, "God, you've got gray hair now," and I think, "Well, that was a long time ago." I guess I'm a dreamer of the past. I like to relive the old Haight. In the last twenty-five years, I have probably slept ten years of it in the park. I'm too old to get a job, I don't like anybody supporting me, I won't go on welfare, and I won't get food stamps. I am homeless; I ride freights when I want to get someplace. I'm a hippie, but I'm a very high advocate of the homeless. I couldn't think of a better place to die than in Golden Gate Park, and I couldn't think of a better place to be buried than in Golden Gate Park. I love this park.

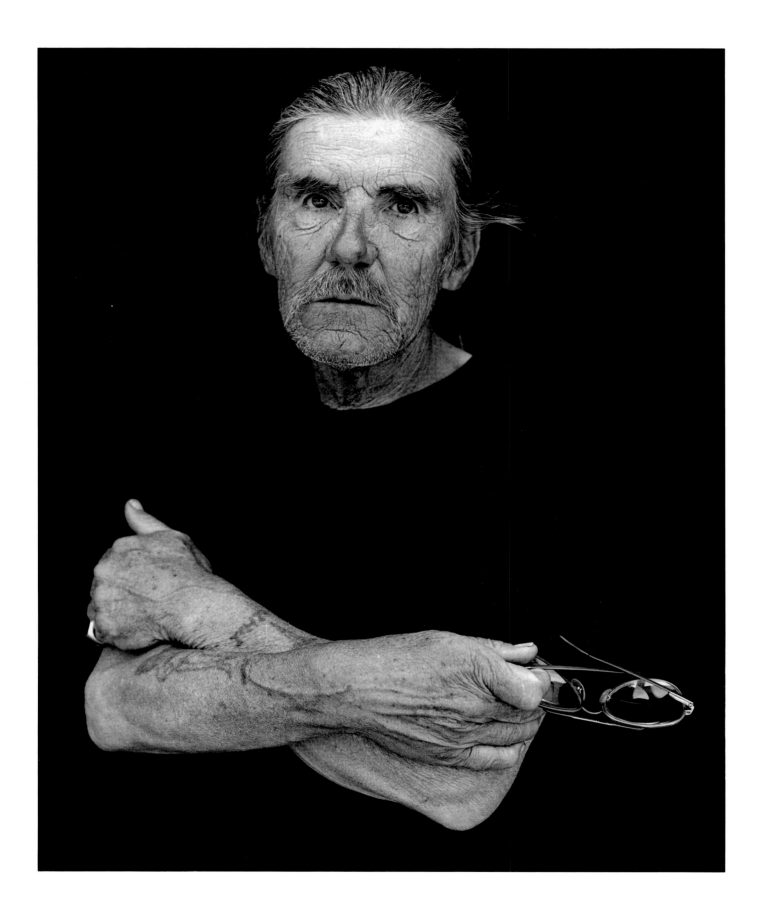

Allison Wonderland, 21 WASHINGTON, D.C.

When I got out of high school, I wanted to travel around the country. My main goal was not to go live in the park, but to be part of the nonconformity. We had our nine-to-five jobs, and a nice apartment, an efficiency, the whole bit. I don't know, there's something about surviving day-to-day that is attractive. I noticed that when I'm with family, they don't look at homeless people like real people. Like my cousin had to come up from L.A. to check up on me. I hadn't seen the man in six years. All of a sudden he comes walking into the park. He wanted to take me out to dinner, and we passed by this restaurant and I said it was a real good restaurant and he said, "Is that by people's standards or by park people's standards?" I said, "That's by human beings' standards." Even my own family doesn't think that homeless people are regular people or regular human beings.

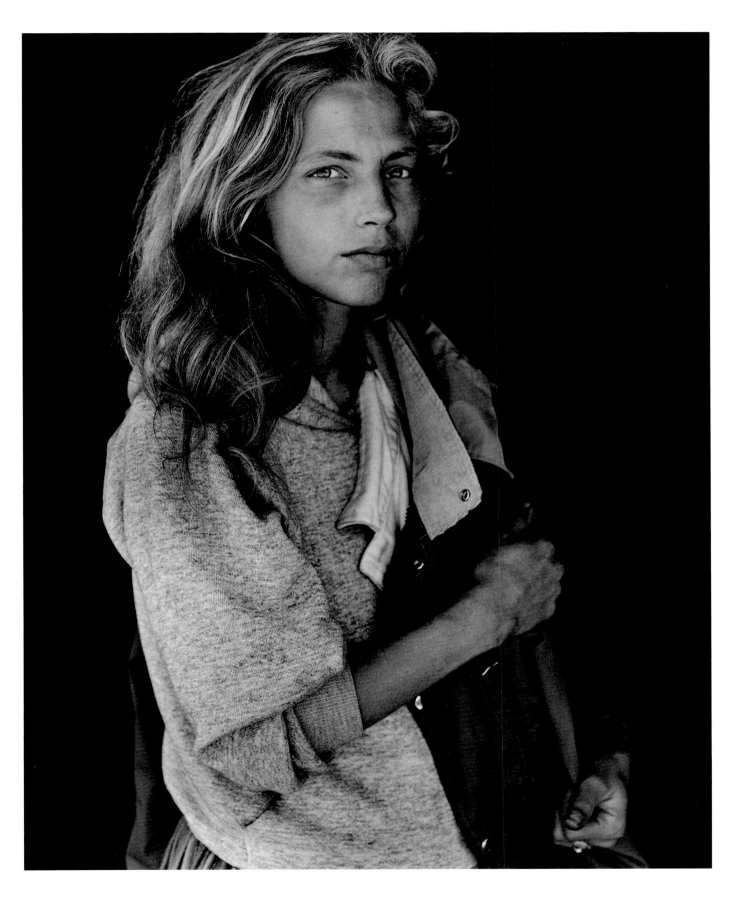

Jackie Lee Shands II, 26 MISSISSIPPI

I'm waiting on a $400 check in the mail right now 'cause I'm on SSI. 'Cause the economy is so unstable and I can't find a job. I've got an adequate mind, but I don't know. I'm too fast-paced or whatever, so they called me a schizoid-phrenic and gave me a check. I've been arrested for runaway. I ran away when I was fourteen. I don't like my parents. They tried to rip me off and tried to control my interests. The reason is my book, which won a major contest in science fiction. My sister, she's the one that got all the paperwork. I didn't sign some, so I'm suing for my percentage. I found the story in my head. An author approached me and said, "I'm going to write a book and make a movie. I may give you honorable mention." The main character in the novel is Jack Crow. He's a vampire hunter.

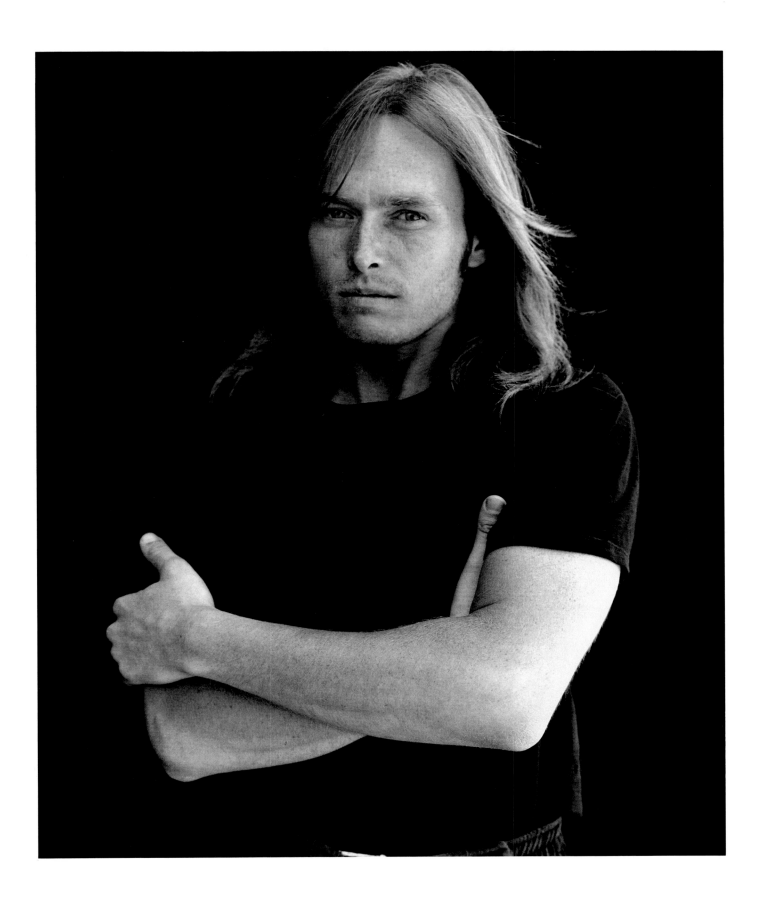

Sheila Wildu, 29 HOUSTON, TEXAS

I want to go home to see my kids. I've got three kids. Two girls and a boy. One, four, and nine. My children are with my mom in Missouri City. My mom's got a four-bedroom house, and the kids are well taken care of. But I move around.

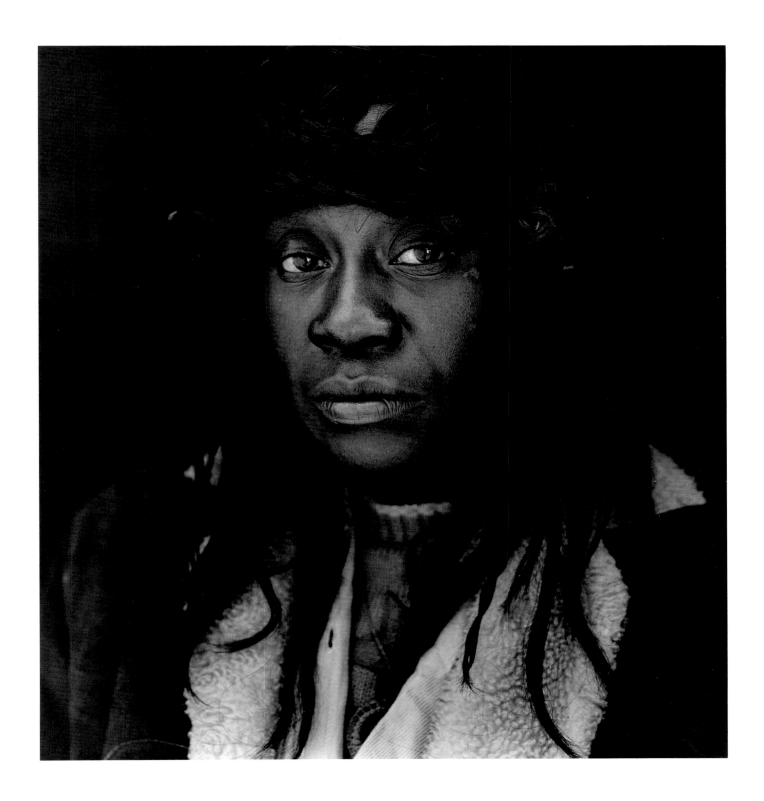

Tim Johnson, 32 ARKANSAS

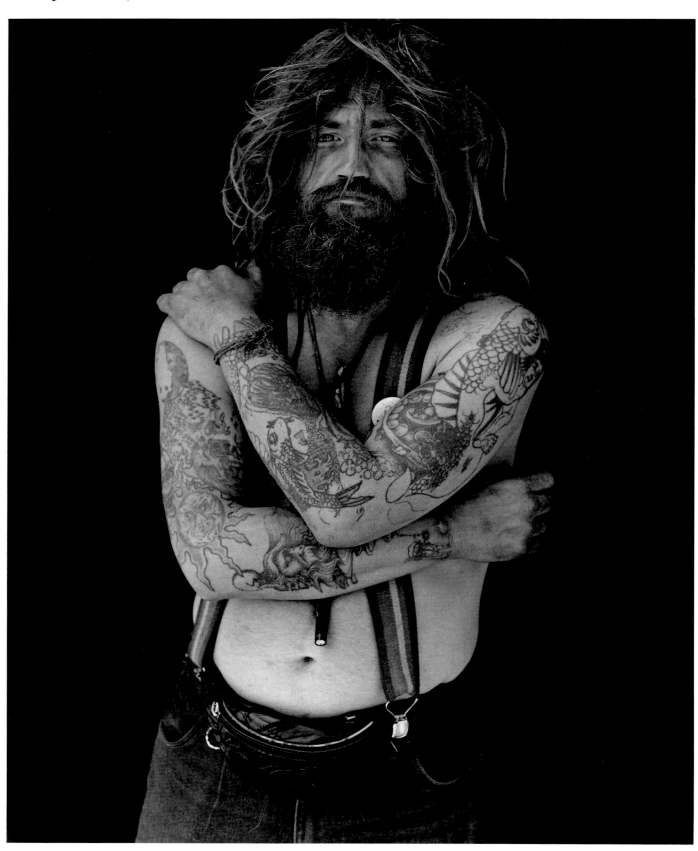

Ralph Yu, 30

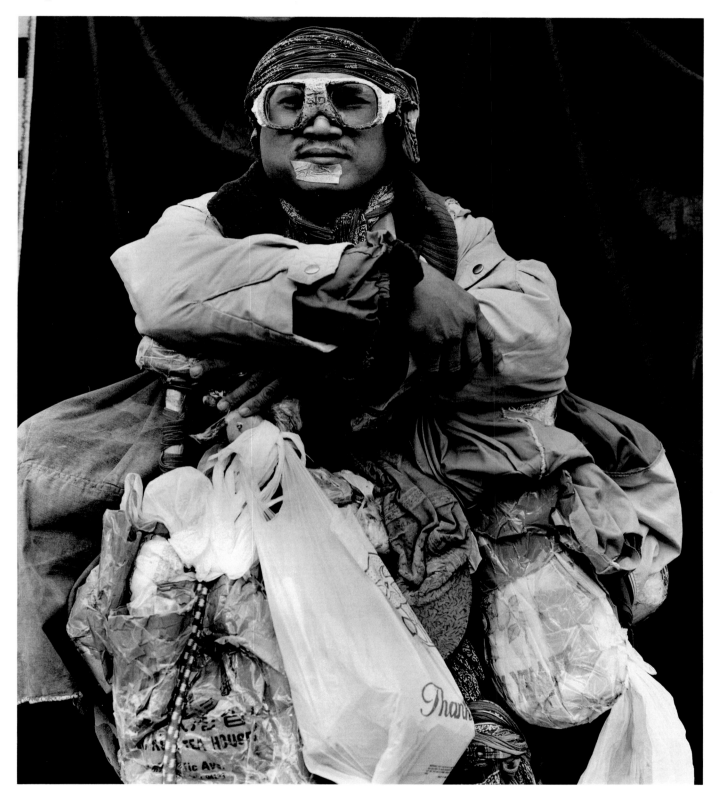

Brandy Hazelett, 29 OREGON

Me and my husband thought we were going to come here and start a new life when we got married. When we came down here, he had work. But the store went out of business and we couldn't afford to pay rent. So, we've been out here ever since.

The problem with General Assistance is that they'll only give you enough to be able to pay for your room and that's about it. You have to make your eating money and your personal needs. I don't get General Assistance because I don't have an ID, and I have to fight for my social security number. I have to go down to immigration and get my ID straightened out, and I have to fight for my social security number.

Homelessness can happen to anybody. It can happen to you overnight. I've seen people where a lot of them used to be really rich, and they'd end up homeless because they either lost their job or a family member died or somebody that would take care of them.

I've got five kids who live with their dad in Portland. I talk to them and stuff on the phone, but I'd like to have them, but I'm homeless and I have no place to take care of them; I'm waiting to get off the street before I get them back.

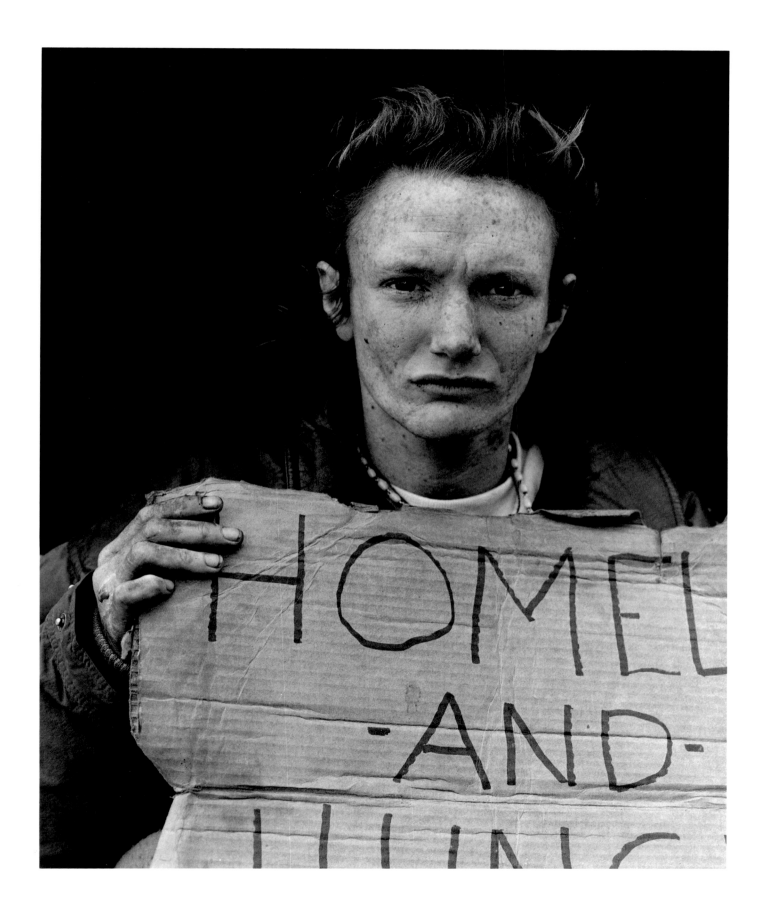

Ludwig Brandt, 48 DETROIT, MICHIGAN

All my life I worked for the car company back in Detroit—I put about nine years in the car company—and then they started buying these Japanese products and I got laid off. Everything just fell, tumbled down on me and then I started—well, I was always boozing it. The car company I worked for you could booze in the parking lot. Even got drunk with the boss. And my parents didn't care. They would laugh at me. Becoming an alcoholic is just like a signature for me. It wasn't like "no-no, don't do this." It was like "ha, ha, ha." I've been homeless off and on about seventeen years. I've moved around. I went to Texas. I hopped the freights and all that kind of garbage since '75. I get welfare and I get panhandling money. I sleep in alley streets. My friends give me blankets and stuff. Sometimes I stay at shelters. In Michigan, my whole house payment was $258 a month. I just choose to be homeless because I cannot see paying over $100 a week rent when I used to have a house with a 65-by-130-foot lot. I got mad at my wife and I got divorced and I started drinking a lot. I'm an alcoholic and I didn't want my kids to go through the trouble of seeing a drunken father. They are better off without me. I'm an alcoholic. Being really, really drunk makes me put up with crazy reality.

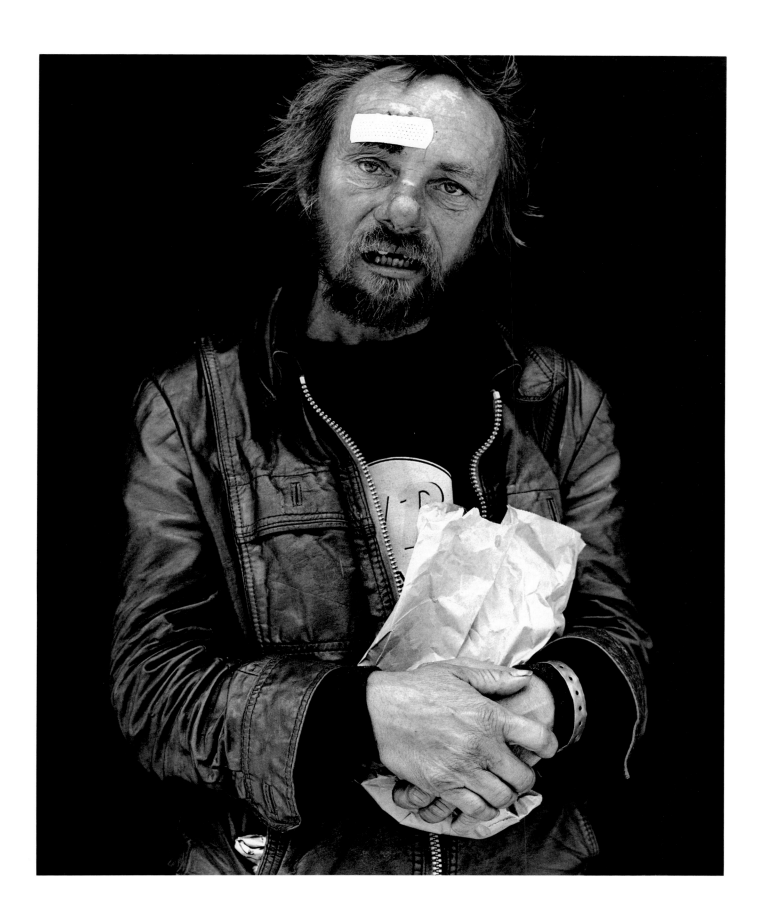

Chris Wallace, 24

The people that you see out here you might think that they're stupid, ignorant, dumb, and lazy. It's totally the exact opposite. All these people out here have very, very high IQs. That's how they survive this long—the way they are. College is very well and fine, but how many will receive anything from the college of life? That's really the education. It's every day. Every encounter with a person. What have you learned? To take with you into the next day so you don't have to relearn it again? The Aquarius Age is coming up soon, and my invention will spiritually uplift people in a very well-managed way. It's not patented at the moment, and I'm waiting on my patent applications, but everyone will come to know it. It's called the audible pyramid. We are working with pyramid energy here. That's very wonderful about California. All the settlers came here. People are very conscious about everything; other places, people are so scared. People with the bravado, with the attitude and the consciousness of searching, finding that wonderful bliss, that divinity we know within the human shell.

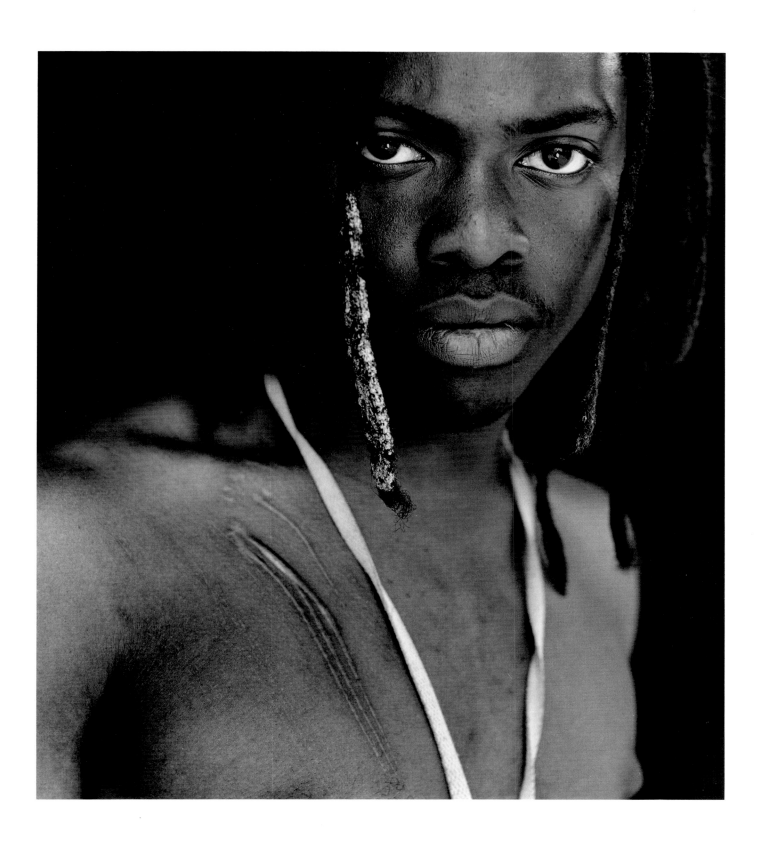

Cathy Stevens, 36 SAN FRANCISCO, CALIFORNIA

I've been looking for work off and on. But a lot of jobs require that you have a driver's license, and I lost mine a while back. I got to go down and get it because I do janitorial work. I paint houses and stuff. I like doing that kind of work.

I see a finished product. I couldn't sit behind a desk. I'd go nuts.

I've been out of prison for a year and a half now. I caught a case in '84. It was a drug charge. Somebody had drugs on them and they said I strong-armed them into carrying my drugs. It took me eight years to get out for parole.

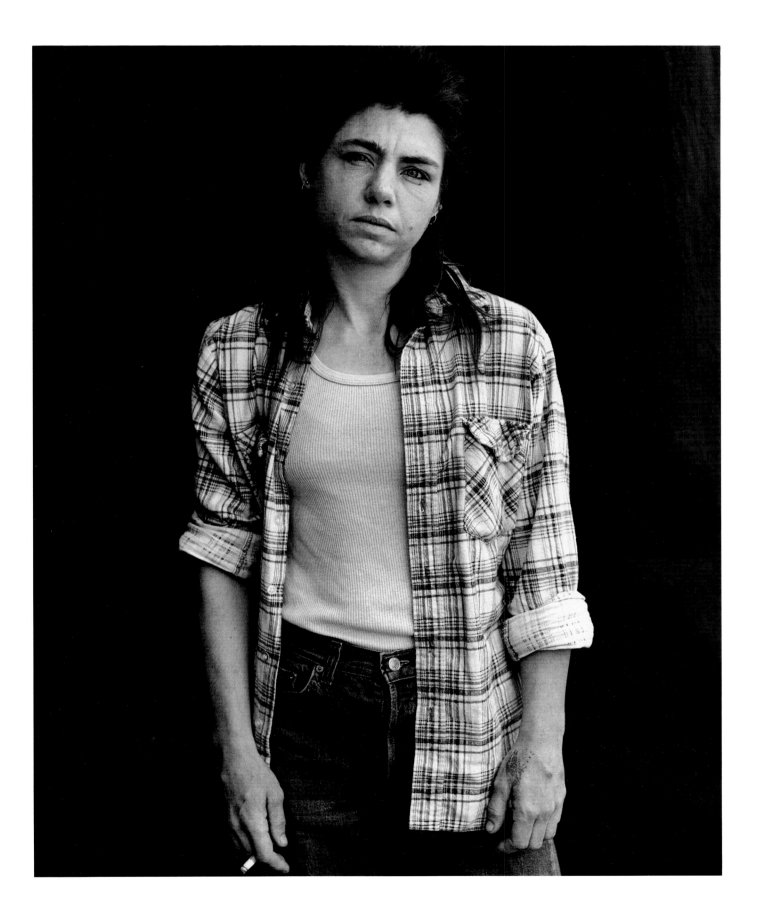

David W. Ware, 39 SACRAMENTO, CALIFORNIA

I come to the park to get away
from people. From drugs, dope
fiends, and rock heads. I feel a lot
of 'em are lazy. They want to
panhandle and live off the
people, but there's other ways of
doing things, an honest way. I've
been doing it since I was twelve.
A lot of it's drugs. I was born a
heroin addict, an alcoholic, and I
lived in an incubator for a year.
Almost died cause of an enlarged
heart. Been alone since I was ten,
eleven years old. My mom was a
drug addict. All I can say is that
this ain't no life for anybody out
here in this world.

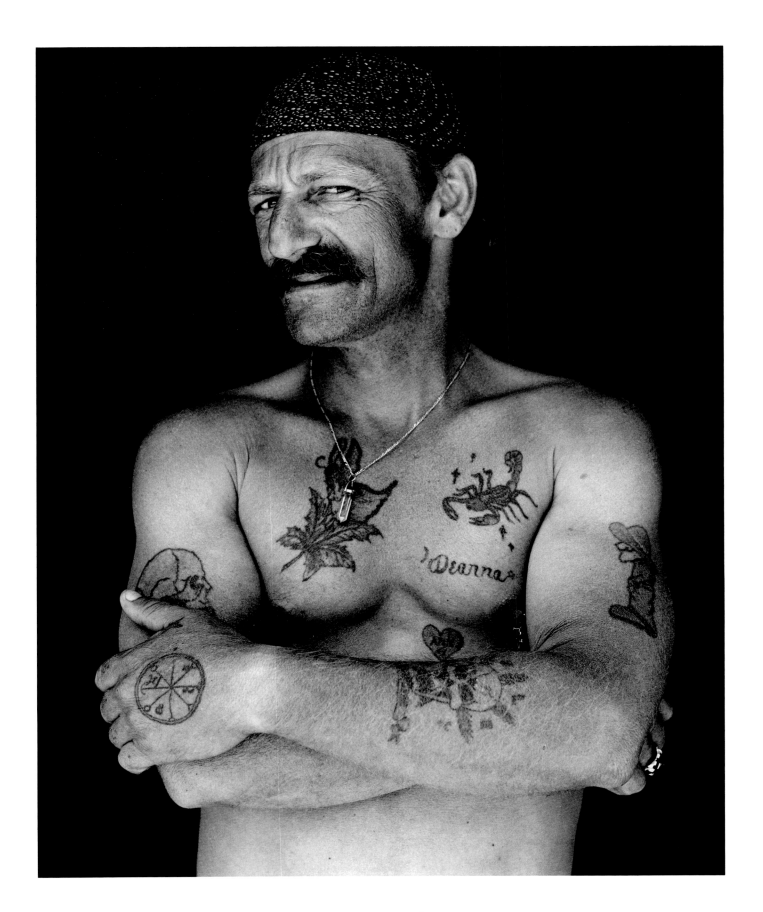

Sally Thomas, 89 SAN FRANCISCO, CALIFORNIA

I don't drink, or smoke, or use dope. And I try not to eat any more salt than I can help, or any of this fat lard off of this red meat. I ran away from home when I was about eight years old. My mother married a drunken Irishman soldier, and he used to beat her and me up so I ran away from home. I was able to live in some of them old barns and get fruit off of trees. Then I got a job helping a woman paste labels on these wine grapes. So, I made my first hundred dollars there, at ten cents an hour. I helped someone that had a tractor to get jobs around that area that had orchards. I worked for about a year or two disking orchards for people and pulling that tractor. I got awful close to getting married. I was tickled to death, but whatever my mother and my parents and relatives went through, I didn't want to go through. And I've seen so much trouble around, I wanted to be my own boss.

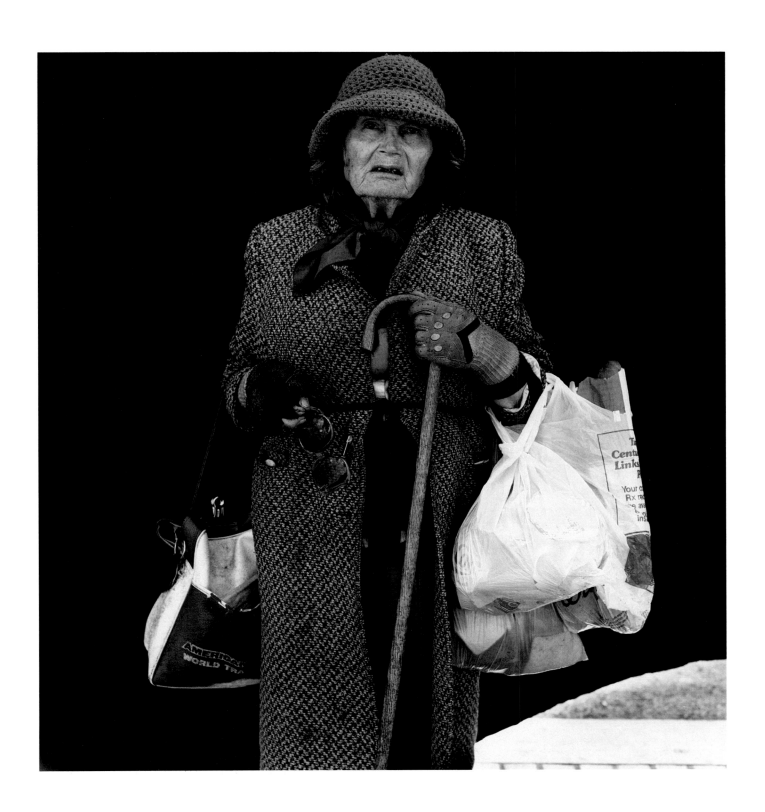

Troy Donaldson, 7 MILWAUKEE, WISCONSIN

Renee Rosetti (mother of Troy): I came here from Milwaukee about three months ago; my brother was supposed to meet us here, and he wasn't there so we were homeless. I didn't have any savings or anything. The first night we slept in a car. The next morning we finally found a shelter. My son's dad is in prison. He was an alcoholic and a drug addict. It's been horrible. It's been a nightmare.

I was working part-time as a clown. I used to work in parades in Los Angeles. Back then I joined the circus, and I traveled with the circus for a while. Now I'm trying to be a musician. I play blues harmonica and conga drum. I go to different nightclubs and jam with different groups. In Milwaukee, on AFDC, it was $440 a month and food stamps. Here it's $511 and less food stamps. So they give you just enough to cover your rent for a very small place, like a studio, and then enough to pay for maybe half of a month in food. They give you the bare necessities and then they expect you to either go to the free food centers that they have, or work part-time. You have to do that or else you'd never make it on your own.

I thank God for the AFDC in at least paying for the rent. Because then I can give the time that my son needs. I tried working at night, and I'd be half asleep during the day. And there's no way you can take care of your kid when you're half asleep. What scared me the most about getting stranded at the bus depot was all the bums hanging out in the terminal. I felt like I'm a bum here, I'm stranded. I hope I don't have to sleep on this bench here. With my son. And then I called eight shelters. I looked in the Yellow Pages, and they all told me that they had no room. Eight. I called

eight of them. That's why I ended up going to try to find my brother. He was afraid to see us because he feels so guilty. He won't even come and see us. And I feel bad, too, you know. But it's not my fault. He should have at least thought about his family a little bit, instead of letting us go through all this hell, because it was sort of hard where we were at. There were all these gay people there and SSI people living there—crazies. So we were exposed to a lot of bizarre things that I had never seen before, either. And they shouldn't really integrate people like children and mothers with SSI people and gays. Because a lot of these gays are so perverted. They like children, too, young boys and all that stuff. It's really disgusting. I had to warn my son about a lot of things, and to be careful.

If I had to tell my parents I was in a shelter, I'm sure they wouldn't think I was a very fit mother. They aren't real eager about giving me money. They figure I've gotten myself into this situation with his dad, that I need to do it on my own.

It makes you realize that you can lose everything in two minutes. Not have a place to live, not know where to go for anything. But thank God for these places like Traveler's Aid that helped us out. If it wasn't for them, I don't know. We would have probably ended up on the corner begging for money to get to Milwaukee or something.

I came from a background of not very much of a family that really cared about the kids. There wasn't a lot of love in my family. You couldn't ask my parents for money when you needed it. You were sort of afraid to. They live in a huge place that looks like a

lighthouse. It doesn't matter what your background is, you can end up in these situations. If there's a lack of caring in your background, I think that's probably what it is, basically. It leads you on these weird paths.

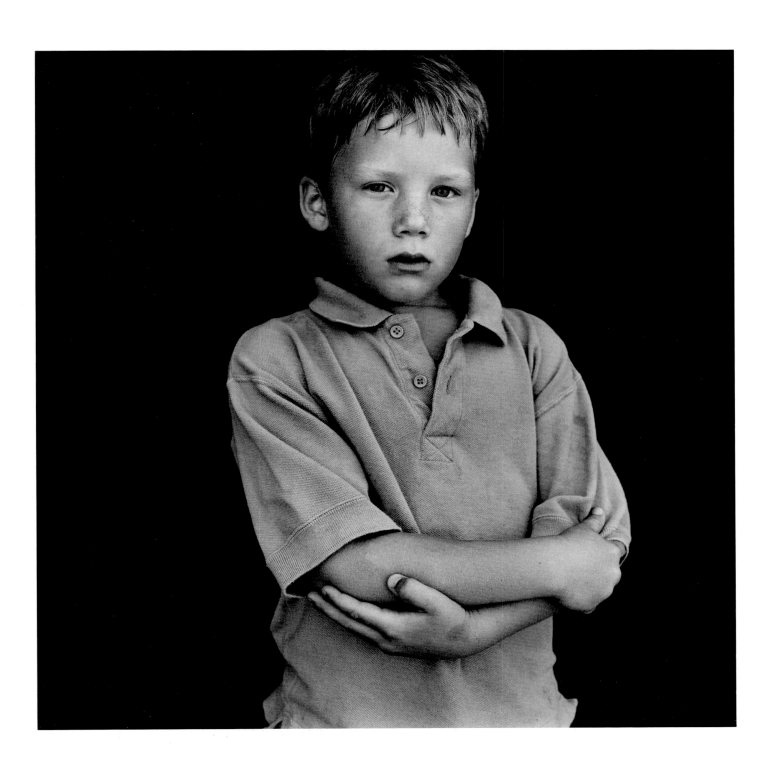

Cherise Irving

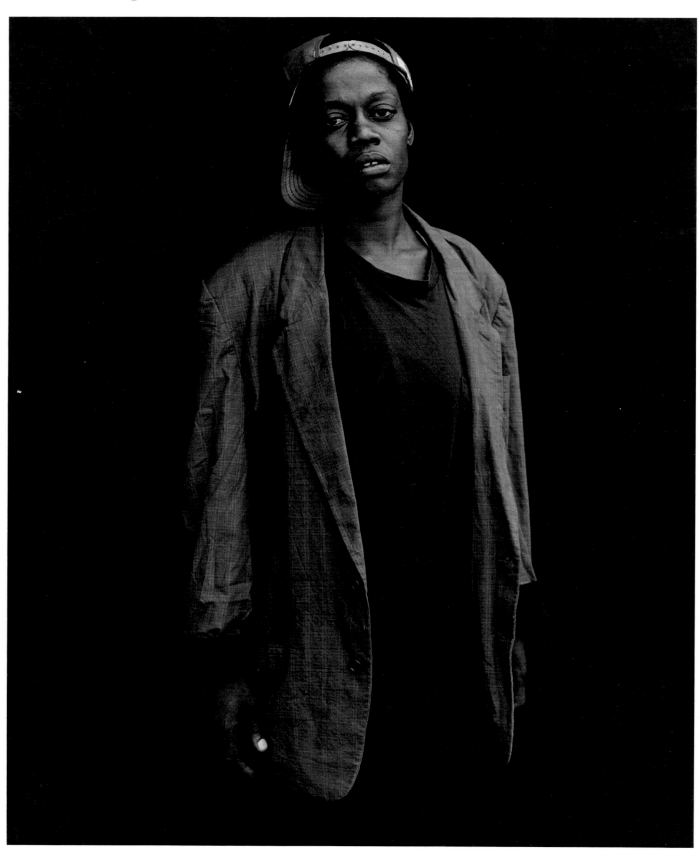

Susan Pettis

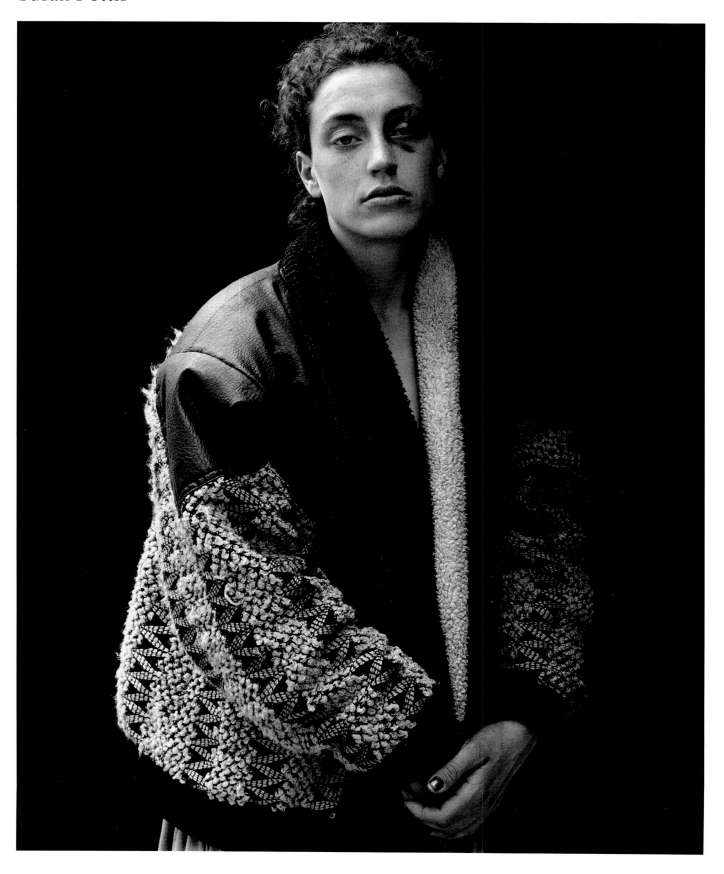

Dave Badesheim, 25 COOS BAY, OREGON

If your life is in a rut
Or there's a lot inside your gut
Or your problems seem so near
Don't be overwhelmed with fear
Just have faith in God above
Cause God has blessed our lives
 with love
When Jesus shares a ray of light
Then he can help us make things right
And try to forgive your fellow man
Cause it's not hard to understand
It's simply able to forgive
Your hatred's gone, it cannot live
In Jesus name, Amen.

I was raised in a small, mid-western town. But I'm a fool for the city. I've been living in most of these major cities up and down the coast for about ten years. On the streets, mostly, in the park or alleyways.

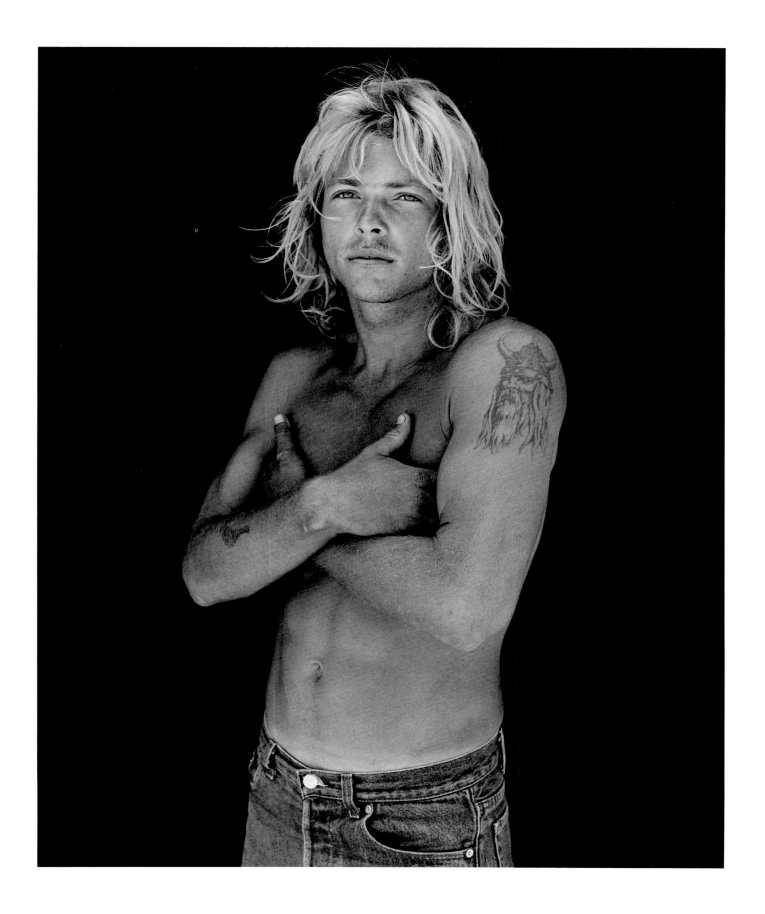

Jessica Stewart, 41

We live behind a donut shop, in a parking lot. It's not so bad. It's a 24-hour place, and they give us free donuts occasionally. Before, we were in the park. Until they started turning the sprinkler system on us. Couldn't stay out there anymore, we got totally wet. I had a stroke six years ago, and I haven't been able to get proper medical attention to get better. My legs got worse and my back got worse, so I got the wheelchair. I was in a very bad marriage before. It got so intense, and I was being beaten and verbally abused. I just decided to leave him altogether.

I worked as a telephone operator. My last job, I was working at telephone sex. It paid seven dollars an hour. And it was a job. And it kept me paying my room. But then the court ruled against that, so they had to close the place down. But it was a job. And I was very good at my job. I won an award the last month that I was there. I made an extra hundred dollars a month. But those times are over, so I don't know what to do. Unless something changes here, I don't know how we're going to see daylight. I'm going to try to get off of the streets some way. I'll go into programs maybe, because my body will not allow me to stay out here too much longer.

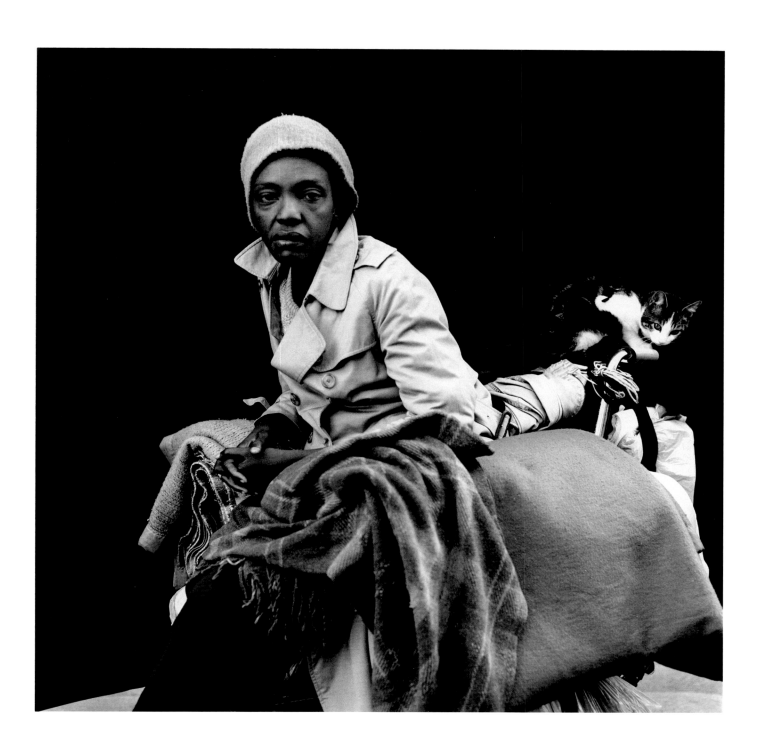

Mike Siebenlist DENVER, COLORADO

I came here in 1964. I've been a technical illustrator and a draftsman for 30 years, and I picked up sign painting as a thing to do. More independent. That way you don't have to have an employer, you have clients. Right now I collect cans. It's real easy. You're out on the street, you're in the sun. You don't get that in regular work. I love being outside in the weather, in the rain, in the snow.

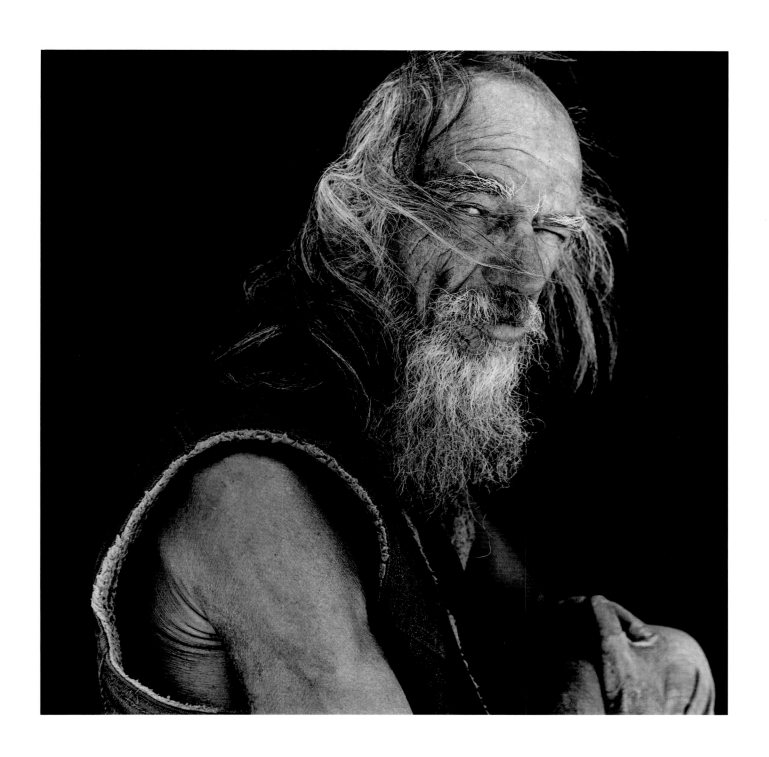

Kenneth Ware, 40 DETROIT, MICHIGAN

Right now I'm unemployed, but when I'm working, I do labor and I do heavy equipment. I'm homeless. I'm living in the streets. It's very tiresome. Very boring. They got a lot of shelters you can go to. Sometimes I would prefer the streets 'cause I ain't gotta deal with a lot of people and I can just stay out on the streets. If I gets too tired and I need to clean up, I go in a shelter.

I drink. I use drugs, too. I've been using drugs ever since I was nineteen years old. Been in and out the penitentiary. I usually use heroin, but now since they come up with this rock, I started smoking that. I'd rather use heroin 'cause you don't have to spend that much money—heroin, you can only do so much of that. But rock, you could smoke that shit all day and night and spend all your money.

Since I been back, I been havin' some problems. I had a stereo sent from Ogden the other day, and I sent it through the post office and it came here tore up. So I went off, lost it, and they put me in jail for a few minutes till I cooled down. I had just bought the stereo and I worked pretty hard for it. I worked for a dog food place in Ogden, so when it got here—I spent $200 for the stereo—when it got here it was damaged. And instead of me keepin' a light head, I went off, started cursin', you know, and they thought I was going crazy, so they called the cops on me. They took me to jail. Just for a few minutes. So he let me go and gave me my box. Yesterday I sold it. I feel kinda bad about that, but, I'm on the streets, what am I gonna do, walkin' around with a big box like that anyway?

I'm gonna get out of this cycle, you know, 'cause I'm a working-type person sometimes. And if I stay, I'm gonna get bored with G.A. 'cause it ain't no money and I like clothing. I like women. It's very lonely. It's very hard, too. You try to find someone that, you know, you can be with and share with. Life ain't over with for me yet, I'm not that old yet, so I still probably can have children, you know. So, I'm not, I'm not dead yet, so when I do, when I do get a certain age, I say like 50, that's when I'll just forget everything about family and all that, but right now I'm young, so I'm all right.

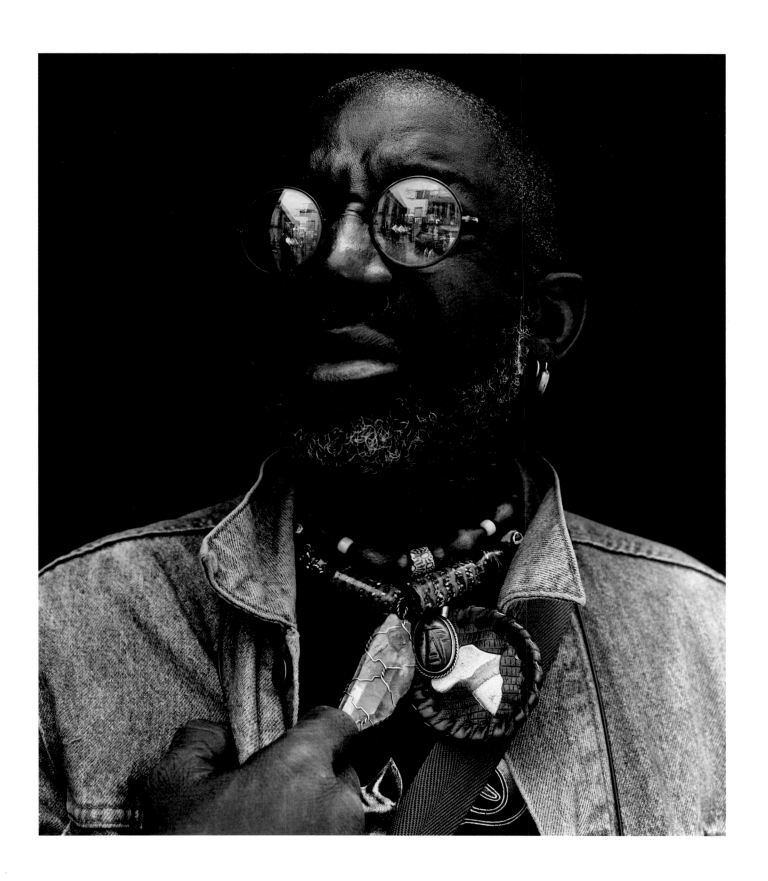

Dorthy Knudson, 32 GERMANY

I sent my four children back to my mom and dad in Germany when there was no work. It's humiliating out in the street, but I'd rather panhandle than be on welfare.

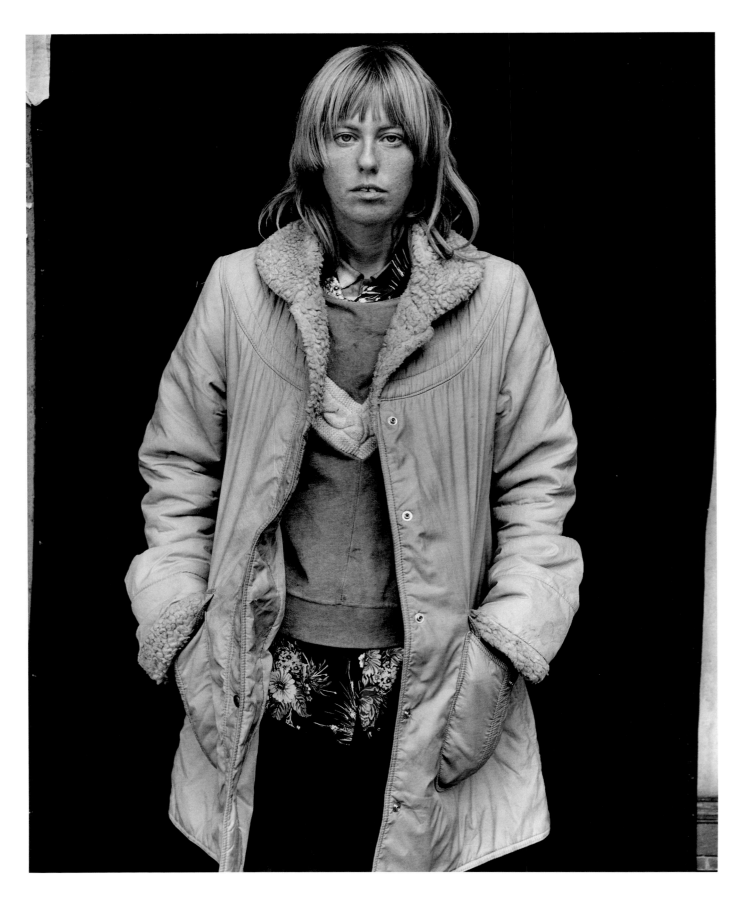

Jubilee Hasty, 21 ARCATA, CALIFORNIA

A homeless person is someone that's lost. The earth should be your home; you should realize how to get your own shelter and that the earth totally provides for everybody. It's up to you to cultivate your own spark and get what you need. "Homeless" is the wrong phrase. The phrase should be "destitute." Everybody's destitute from time to time. But homeless is wrong, 'cause I own the ground that I stand up on and that's what gives me strength and faith. I like to live in the woods when I can, since I was about thirteen years old, because it is much more airy and it's a lot healthier environment. Friends usually have houses that have water. In many towns there's the YMCA and for $1.50 you can take a shower. I choose not to live in a house. I have a very good tent and a lot of friends.

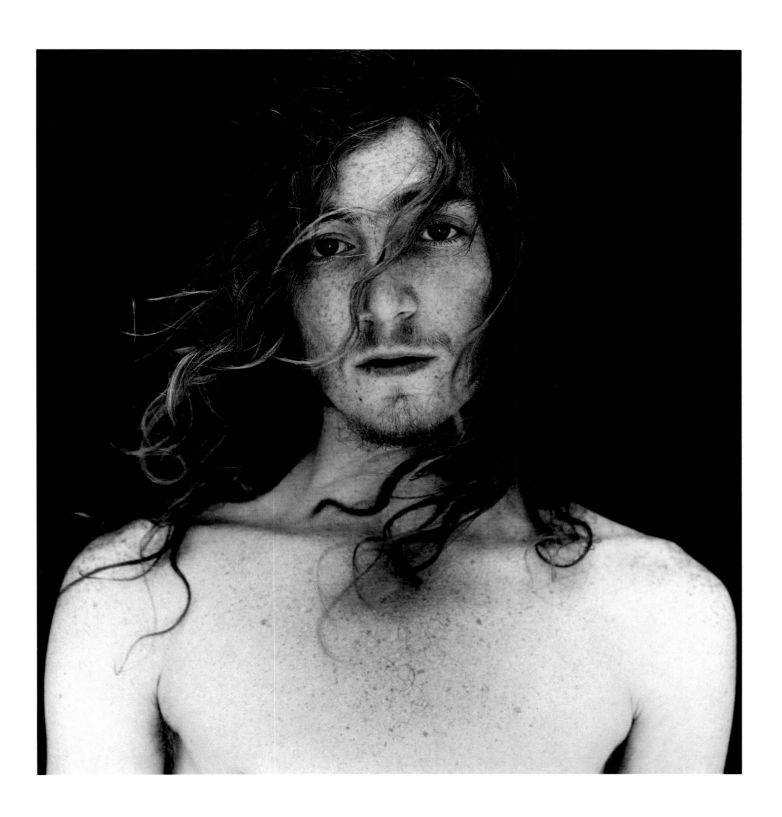

AFTERWORD

The Homeless Assistance Act of 1987 defines a homeless person as one who lacks a fixed, permanent nighttime residence or whose nighttime residence is a temporary shelter, welfare hotel, transitional housing for the mentally ill, or any public or private place not designed as sleeping accommodations for human beings. In the last decade, homelessness has become one of the most important and challenging social problems in our country. On any given night it is estimated that 567,000 to 735,000 Americans are homeless. Annual increases are estimated between 15% and 50%. While men without children compose the largest group of the homeless, families with children are the fastest growing component.

The Stanford University Center for Research in Disease Prevention recently completed a scientifically designed survey of 1,500 homeless adults. The findings give an overall view and understanding of homelessness in America in the 1990s. Two-thirds of the homeless are between the ages of twenty-five and forty-five. Only a few are elderly, a finding in contrast with studies conducted thirty years ago when there were ten times more elderly homeless. With the exception of Asian-Americans, ethnic minorities are overrepresented, composing about 50% of the homeless. This is consistent with their overrepresentation among the poor in general.

Contrary to commonly held beliefs, the large majority of the homeless in our sample were raised in middle- or upper-income homes. Sixty percent graduated from high school; almost one-fourth attended college. Before their current episode of homelessness, 78% of the men and 43% of the women reported that their primary source of income had been from their

own jobs (2% of the men and 15% of the women had been supported by public assistance). Men had been employed longest in blue-collar jobs while women had worked longest in non-professional white-collar jobs.

When asked about their childhoods, 10% of men and 16% of women reported being removed from their parents and placed in foster care before the age of eighteen (56% entered foster care before age ten and 44% at age ten or older). Six percent of the men and 29% of the women said that they had been sexually abused as children, and 13% of the men and 26% of the women said that they had been physically abused.

Most people in our study first became homeless during young adulthood: 52% by age thirty, 82% by age forty. Forty-three percent had been homeless more than once, and over 35% had spent more than one year without shelter.

Stereotypes of the homeless result from seeing those who manifest the most severe mental and physical health problems and are therefore the most visible. Our survey confirmed that some homeless people have significant psychiatric and substance abuse problems—about one in three have used alcohol excessively, and one in four to five have used illegal drugs or have been hospitalized for psychiatric problems. Homelessness exacerbates the problems of the visible homeless; the longer they remain without shelter, the more severe their problems become.

But those who are the most visible do not account for the largest proportion of the homeless. Seventy percent of women and 50% of men in our survey reported no addictive or psychiatric disorders before they first became homeless. These are the invisible homeless, about whom we know little because their more normal appearances and behaviors allow them to blend in with the rest of the population. Although initially unimpaired, homelessness causes the onset of alcohol, drug, and mental problems in some of these individuals, and over time, they enter the ranks of the visible homeless.

Case histories concerning personal risk factors that precipitated homelessness included a variety of problems in addition to those related to addictive and psychiatric problems. These risk factors include family breakup, domestic violence, illness or death of a family member,

and victimization in crimes such as robberies of rent money or work tools. These crises were especially difficult to surmount when an individual was without adequate financial or social resources.

Apart from their personal risk factors, virtually all homeless people are victims of societal forces and the economic problems that occurred in the last decade. Young workers, like those in our study, encountered an economic recession in the late 1970s that produced levels of national unemployment exceeding 10%, the highest levels since the 1930s. While unemployment increased among all workers in the decade before 1985, rates for African-American men increased the most, from 9.3 to 15.3%. High levels of unemployment were coupled with high rates of inflation that reduced the buying power of average hourly earnings, especially for young workers. In a twenty-year period, the earnings of workers under thirty-five declined to about 80% of their 1968 levels while the earnings of older workers aged forty-five to fifty-five increased to 125% of their 1968 levels. Women respondents told how their families were negatively affected as men became less able to make sufficient economic contributions to their households. Furthermore, those who were single had no opportunity to maintain their standard of living by being a member of a two wage-earner household.

With higher levels of unemployment and decreases in real wages, respondents described their need for affordable housing. Low-income housing, however, was substantially depleted during the 1980s due to cost restraints and the economic restructuring of urban cities. During this decade, for example, federal housing assistance programs for the poor were cut by over 75%, and appropriations for low-income public housing fell from $30.2 billion to $7.4 billion. Approximately 2.5 million units of low-cost housing were lost to conversion, abandonment, arson, and demolition, and over one million single-room occupancy hotel units, a segment of low-income housing commonly available to single adults, disappeared from the housing market between 1970 and 1982.

The difficult economic situation was exacerbated by a number of policies implemented during the 1980s that changed America's social institutions. Beginning in the early 1980s, social services for the poor were cut and eligibility criteria became more stringent. Increasing

numbers of Americans had inadequate or no health insurance coverage. Thirty-seven million Americans are medically uninsured; three-fourths of all adults without children and one-fourth of all families with children which we interviewed have no health insurance.

New policies resulting in stricter requirements for social security disability insurance and rules such as those requiring an address before coverage is granted appeared to affect our respondents to a large degree. For example, we interviewed two men who had been discharged from the hospital before receiving disability insurance. Upon discharge, they became homeless because they were unable to afford housing—one was a young construction worker who had lost both legs in a work-related injury, the other was a veteran who had sustained severe burns while in the service.

Changes in the mental health care system during the 1960s and 1970s also contributed to the growing numbers of homeless during the 1980s. In California alone, the number of people in state mental hospitals decreased from 37,000 in the early 1970s to less than 5,000 today. The lack of adequate funding for community mental health services creates a competition for limited inpatient and outpatient treatment programs. This problem is compounded as those from the baby boom reach adulthood and increase the number of people at risk for developing severe mental disorders.

Most of us will never become homeless—we will never join soup kitchen lines, sleep in cars or cardboard boxes, or experience the hopelessness, fear, and isolation that accompany the loss of shelter; nor will we suffer the deleterious impact that homelessness has on mental and physical well-being. And yet, we will all continue to be influenced by this complex social problem. Our responsibility is to avoid stereotypes and to be actively involved in this national crisis that threatens the health and future of a generation of American people.

Marilyn Winkleby, Ph.D.

Senior Research Scientist
Stanford Center for Research in Disease Prevention
Stanford University School of Medicine, 1993

REFERENCES

Bassuk, E. L. 1984. The Homelessness Problem. *Sci Am* 251:40–45.

Blau, J. 1992. *The Visible Poor: Homelessness in America*. New York: Oxford University Press.

Breakey, W. R., P. J. Fischer, M. Kramer, et al. 1989. Health and Mental Health Problems of Homeless Men and Women in Baltimore. *JAMA* 262:1352–1357.

Brickner, P. W., B. C. Scanlan, B. Conanan, et al. 1986. Homeless persons and health care. *Ann Intern Med* 104: 405–409.

Burnam, M. A., R. L. Hough, J. I. Escobar, et al. 1987. Six-Month Prevalence of Specific Psychiatric Disorders among Mexican Americans and Non-Hispanic Whites in Los Angeles. *Arch Gen Psychiatry* 44:687–694.

Burt, M. R., and B. E. Cohen. 1989. Differences among Homeless Single Women, Women with Children, and Single Men. *Soc Probl* 36:508–524.

Committee on Health Care For Homeless People, Institute of Medicine. 1988. *Homelessness, Health, and Human Needs*. Washington, D.C.: National Academy Press.

Davis, L. A., and M. A. Winkleby. Sociodemographic and Health-Related Risk Factors among African-American, Caucasian and Hispanic Homeless Men: A Comparative Study. *J Social Distress and the Homeless* (in press).

Edelman, M. W., and L. Mihaly. 1989. Homeless Families and the Housing Crisis in the United States. *Children and Youth Services Review* 11:91–108.

Fischer, P. J., and W. R. Breakey. 1991. The Epidemiology of Alcohol, Drug, and Mental Disorders among Homeless Persons. *Am Psychol* 46:1115–1128.

Gelberg, L., and L. S. Linn. 1989. Assessing the physical health of homeless adults. *JAMA* 262:1973–1979.

Hopper, K., and J. Hamberg. 1984. The Making of America's Homeless: From Skid Row to New Poor, 1945–1984. In Bratt et al., eds. *Critical Perspectives on Housing*. Philadelphia: Temple University Press.

Koegel, P., and A. Burnam. 1988. Alcoholism among Homeless Adults in the Inner City of Los Angeles. *Arch Gen Psychiatry* 45:1011–1018.

Lamb, H. R. 1987. The Homeless Mentally Ill. In *Homelessness: Critical Issues for Policy and Practice*. Boston: The Boston Foundation, 33–37.

Miller, D. S., and E. H. B. Lin. 1988. Children in Sheltered Homeless Families: Reported Health Status and Use of Health Services. *Pediatrics* 81:668–673.

Robertson, M. J., and M. Greenblatt, eds. 1992. *Homelessness, a National Perspective*. New York: Plenum Press.

Rossi, P. H. 1989. *Down and Out in America: the Origins of Homelessness*. Chicago: University of Chicago Press.

Susser, E., S. Conover, and E. L. Struening. 1989. Problems of Epidemiologic Method in Assessing the Type and Extent of Mental Illness among Homeless Adults. *Hosp Community Psychiatry* 40:261–265.

U. S. Conference of Mayors. 1986. *The Continued Growth in Hunger and Homelessness in American Cities*: 1986. Washington, D.C.: USCM.

Winkleby, M. A., and D. Flashing. 1993. Physical, Addictive and Psychiatric Disorders among Homeless Veterans and Non-veterans. *Public Health Reports* 108:Jan–Feb.

Winkleby, M. A., and R. White. 1992. Homeless Adults without Apparent Medical and Psychiatric Impairment: Onset of Morbidity Over Time. *Hosp Community Psychiatry* 43:94–103.

Winkleby, M. A., B. Rockhill, D. Jatulis, and S. P. Fortmann. 1992. The Medical Origins of Homelessness. *Am J Public Health* 82:1394–1398.

Wright, J. D., and E. Weber. 1987. *Homelessness and Health*. New York: McGraw-Hill.

ACKNOWLEDGMENTS

This project needed many people to make it happen. Keris Salmon and Laure Oliver did interviews. Chris Tuger and John Mahoney assisted. The Hamilton Shelter and Traveler's Aid, organizations offering shelter for homeless families, were very helpful. Thanks to Mike Kelly and Bob Barnes, also Charlie Warren and Brian Olcomendy for teaching me much about street life. I am especially grateful to Paul Singer, a clinical psychologist, for his advice. His experience working with parolees, some of them homeless, has helped shape my vision.

Mike McKenzie did "quick" prints. My gratitude to Gamma Photo Lab. Tony, Ernie, Alex, Ken and the others at Gasser's were helpful, as usual. Patti Levey did an enormous amount of work helping me with printing. The body of photographs for this book was edited with the help of Owen Edwards, Linda Ferrer, and Beverly Ornstein. *Image* magazine first published seven photographs from this series in November 1992.

I am very grateful to Milton Glaser, who generously gave of his time and talents to design this book, and to Lena Tabori, who always believed in this project. My heartfelt thanks to Chronicle Books, which gave this volume a home and agreed to donate the proceeds from the sale of this book, along with my royalties, to Comic Relief for the National Health Care for the Homeless.

—*H. S.*